D1144663

The new handmade graphics

The new handmade graphics

beyond digital design

Anne Odling-Smee

RotoVision

A RotoVision book
Published and distributed by RotoVision SA
Route Suisse 9, CH-1295 Mies, Switzerland

RotoVision SA, Sales & Production Office
Sheridan House, 112/116A Western Road
Hove, East Sussex, BN3 1DD, UK

tel: +44 (0)1273 727 268
fax: +44 (0)1273 727 269
isdn: +44 (0)1273 734 046
email: sales@rotovision.com
web: www.rotovision.com

10 9 8 7 6 5 4 3 2 1
ISBN 2-88046-703-9

Book written and designed by Anne Odling-Smee
Cover, divider pages and page numbering: Peter Anderson
Photography: Xavier Young
Research: Hannah Ford
Editor: Ally Ireson
Commissioning editor: Kate Noel-Paton

Production and separations in Singapore by
ProVision Pte. Ltd
tel: +65 334 7720
fax: +65 334 7721

Contents

Introduction: the rough and the smooth

Scrupulous and haphazard, traditional and futuristic, pure and polluted –
the work in this book constitutes an energetic mixture of styles, technologies
and attitudes that represent the most encouraging signs for graphic design
practice to have emerged for several years. Looking now at the contributions
from the fifty or so designers I interviewed for this book, the range of material
and approaches is far broader than I ever imagined it would be – indicating
that attitudes really have changed since desktop publishing began two
decades ago.

The designers in *The new handmade graphics* are no longer willing to put
up with the homogeneity that has been spreading through globalisation
or the widespread use of modern technologies. They are suggesting new
directions but are doing so in a way that is commercially viable as well as
personally inspiring. Perhaps the most striking impression that came out
of the research was the overriding enthusiasm for the subject shared
amongst almost all contributors, as if they were relieved to discover others
like themselves thinking in ways that, until recently, would have been
perceived as old-fashioned or 'anti-progress'. These changes in attitudes
have been emerging because of various, interrelated factors.

Not everyone wants to live in an environment full of polished surfaces,
artificial materials and perfectly designed spaces – generally, people
are attracted to rough edges, natural fibres and mistakes they can see.
Graphic designers are beginning to realise this at a time when their
industry has become increasingly dominated by perfectionist technology.
The last fifteen years have witnessed a period of excess in graphics, with
designers producing complex fusions of computer-generated matter that
have often confused the presentation of information and achieved limited
visual impact. Only now that the frenzy that followed the start of the
digital revolution of the mid-1980s is starting to calm down are its true
implications beginning to be understood. Some practitioners are

becoming aware that because of the ease and speed of digital production, there is a danger of complacency; in general, people are now more equivocal about the benefits of using the computer in graphic design, particularly as a means of creative expression.

The average graphic designer spends about ninety per cent of his or her time working in front of a Macintosh computer. *The new handmade graphics* focuses on the work and thinking of a particular set of individuals and practices who are trying to reduce this proportion by employing a 'non-digital' approach – so the book is an exploration of just one strand in contemporary design practice, not a comprehensive portrait of the entire graphics scene. But before investigating how and why this development is happening, it is useful to look back at recent history.

Graphic design is a key indicator of how technology is being transformed. Designers have to keep abreast of the latest developments to stay competitive and meet, on one side, the technical demands of print and production and, on the other, the commercial demands of clients. Each new invention or discovery initiates a change in production methods, which is followed soon afterwards by a shift in visual style. This is particularly pertinent today, as changes in print technology and the effects they have had on design have probably been greater in the last thirty years than they were in the previous five hundred. The last Monotype composing machine was built in 1975, the same year Microsoft was founded. Since then, the use of computers has rapidly become widespread across almost all professions and, in graphic design, all but eliminated the role of craft as a practical element of the production process.

Initially, people were reluctant to accept computers. They were expensive, difficult to operate and, at first, even the quality of what they produced was unconvincing – for example, Monotype's first digitised typefaces were no match for their letterpress equivalents. There was scepticism amongst graphic designers, many of whom were uneasy about the way these machines threatened to replace certain of their roles, and make the majority of their previous equipment redundant. Nonetheless, the prospect of a tool that could eliminate laborious tasks and enable enormous creative freedom generated an inevitable surge of excitement.

But changes in graphic design have been precipitated as much by cultural and political factors as they have by technological developments. As a profession, graphic design has only existed since the middle of the twentieth century. 'It only became something you could expect to get paid for in the mid-1960s,' says ex-Pentagram partner, Alan Fletcher – expanding to become a separate practice in areas that had previously been ruled by craft traditions, as well as in the realm of film and television. By the 1970s, design had also become an intrinsic part of business in Western countries, at a time when corporate agencies were beginning to replace many of the smaller design firms. House styles were considered essential, every company wanted a logo (following the success of Coca-Cola), and the 'Swiss Style' became the generic look, with its anonymous sans serifs, lack of decoration and rigid adherence to grids. This strain of graphic design became no more than a mass-marketed style that was applied across a wide range of consumer products, leaving little or no scope for individual creativity.

Various experimental movements in graphic design emerged during this time, partly in reaction to this aesthetic uniformity. One was related to Punk, a predominantly London-based street culture of drugs and pop music instigated by the desire to shock. Although they were not produced on a computer, the way Punk fanzine pages were hastily and chaotically thrown together – using no grid and handwriting instead of typesetting – demonstrated the freedom possible in design liberated from the restraints of metal-type composition. In the Netherlands and the US, New Wave became a leading style, led predominantly by Wolfgang Weingart, as he exploited phototypesetting and the technology of film to create new overlays that had never before been possible. Richard Hollis suggested it was in fact Weingart who moved graphics 'into the realm of personal expression' [R Hollis 1994].

During this time, the Polish graphic design scene was responding to its own new social and political climate following half a century dominated by war. The Polish poster received the highest accolades in both Europe and America. Its visual style depended chiefly on drawing, which had become fashionable amongst graphic artists as a means of communicating anti-commercial messages. The posters are bold, humorous and expressive, with sharp colour tones borrowed from

1. Opera poster
Design: Andrzej Pągowski,
Warsaw 1988

Teatr Dramatyczny
w Legnicy
Reżyseria - Józef Jasielski
Scenografia:
Elżbieta Iwona Dietrych
premiera - wrzesień 1988

Bertolt Brecht
Opera za
trzy
grosze

painting. Although the poor reproduction of the printed graphics was often criticised, the typographical execution somehow seems to underline the quality of the design itself – it was a case of artistic expression being more important than technical perfection [1]. As graphic design critic Silvano Capri describes: 'what made the biggest impression on me in Polish graphics [...] was something which is found in both commercial and free graphic work: the awareness of human values, deep faith in life seen as a continuation of other existences in other epochs. Such values are found ever more rarely in our art, which is becoming increasingly tightly enclosed within so-called pure aesthetic intelligence.' This vein of work continued in Poland well into the 1980s, as society was advancing at a slower rate than elsewhere, and designers remained immune to the effects of technological change for far longer than in other countries.

In the rest of Europe and the US, the real revolution in graphic design began in the mid-1980s, when computers became affordable through mass production, and 'wysiwyg' ('what-you-see-is-what-you-get') interfaces replaced the complex programming skills that people had previously depended on. For the first time, people could see on a computer screen a virtual but exact replica of the layout or image that would ultimately be printed or produced. By the end of the decade, deconstructivism was all the rage, a style that stemmed directly from the lack of compositional constraint this radically new digital technology had enabled. Graphic designers began to question or abandon traditional standards, deliberately rejecting typographic conventions by making use of as many variants as possible, and pushing the integration of text and image so far that the two often became interchangeable.

Initially, this work seemed genuinely innovative, but within a short space of time most of it was proved to be no more than stylistic imitation; typically, readers were asked to wade through long paragraphs of barely legible type that they quickly tired of. Even by the mid-1990s, this approach was already looking dated. As communication systems of all kinds were increasing in scope and complexity, there was a growing disenchantment with the ways in which information was being delivered to people. Designers grew obsessed with innovation to the extent that their computers seemed to become more important than themselves. Despite this new intensity, certain developments reintroduced an element of

doubt into design's infatuation with the computer. Multimedia had been heavily hyped during the 1980s, but only a matter of years later there was already the feeling that CD-ROMs were a waste of time. 'The technology is boringly slow, the interfaces clumsy, the mainstream product banal, and who really wants to spend large chunks of their leisure time gawping at computer screens?' wondered design critic Rick Poynor [R Poynor 1998].

Today, design has become as much a part of our collective lifestyle as fashion and music. People are far more visually aware than they were thirty years ago, and increasing numbers have access to high-quality, well-designed consumer goods, websites, television programmes and so on. The demand for sophisticated media design has led to mass production, and the computer has acted as an equaliser, erasing the difference between text, images, sounds and films. As a result, everything has become homogenised – a magazine feels and looks like food packaging in a supermarket. As a result, most design succeeds in generating only a brief moment of interest that is quickly forgotten and that allows little opportunity for imaginative engagement.

Having grown increasingly service-led, design has become more about client liaison and less about creation. Clients now appear to have a stronger preconception of what they want from a visual product and often assume they know how to achieve it through their own experience of digital processes. Graphic designers increasingly find themselves acting as technicians, operating machines with the client standing behind telling them to 'make it bolder', 'move it up a bit', or 'stretch it out'. Far more work for the individual designer is involved than before, when specific roles such as typesetting would be allocated to other people – they are now churning out work at such a rate that little or no time is left for creativity.

A new group of designers are reacting to this state of affairs, however. Although perhaps creatively disengaged while they fell under the spell of computers and their capabilities, they are now no longer seduced by the likes of photodisc CDs, presented to them like package holidays, with source material available at the push of a button. Many designers are bored with defaulting to Helvetica, having lost the motivation to trawl through ever-longer lists of fonts. And they are fed up with using other people's image-making systems like recipes, where ultimately any

creativity is down to the software's programmer. 'In the field of digital art,' comments John Maeda, 'an entire generation of creators shop at the equivalent of home-improvement megastores, eagerly acquiring all kinds of prefabricated components and add-ons. Blissfully unaware – or even worse, uninterested in – the basic nature of the technologies they are using as tools' [J Maeda and N Negroponte 2000].

By rejecting the computer as the sole means of production or of generating ideas, certain individuals and practices are trying to regain the skills they have lost by returning to a more traditional approach to design. Handmade elements that by modern standards seem labour-intensive and costly are increasingly finding their way into books, magazines, exhibitions and even onto websites, while the computer and its software are treated increasingly as just an additional set of tools. The generation that has grown up with computer technology is now being challenged by the work of the 'do-it-yourself' generation. As design writer Michael Worthington outlines: 'Design has moved beyond the creative possibilities of electronic media to incorporate a new methodology [...] do it in your home, distribute it yourself, copy, master or sample' [M Worthington 1999].

While many designers strive to keep up with new technologies and the latest design 'fashions', this group is searching out more analogue, low-tech solutions for their design briefs. Now that there is a growing disillusionment with complexity, and an awareness that special computer-rendered effects are often a camouflage for a lack of creativity, increasing numbers have been experimenting with reductive, rather than additive methods of working. Making things quick and easy to understand is a requirement now more than ever. Companies such as the Conran Group in the UK are already changing the visual style of their publications, replacing lavishly produced presentation packs with cheaper, more modest publications that deliberately expose the process of fabrication as a gesture of sincerity. These attitudes are also – often cynically – linked to concerns for the environment, with visual elements that suggest 'handmade', 'recycled' or 'organic' being favoured in the design process.

The computer is a complex tool, and it is the same tool used by everyone the world over. As the influence of the West penetrates into the consciousness of increasing numbers of global communities via an

ever-expanding market for its goods and, as a result, cultural differences diminish, designers have to work harder to resist homogeneity. Ironically, as Third World countries struggle to catch up with our technologies, we are beginning to go back and exploit the kind of processes they are still forced to use by economics. Our graphic designers are now travelling further afield to places where older methods such as screenprinting are cheaper than they are at home [p. 25]. The added benefit of international travel is the potential for fresh inspiration, as designers gain exposure to other styles and cultures [p. 112].

In a recent article, Andrew Blauvelt wrote: 'This is an inverted world where the ordinary stands out from the crowd as a distinctive gesture [...] what seems trivial and tangential becomes essential, like so many bits and pieces of data in the detritus of the information age' [A Blauvelt 2000]. As towns and cities become overrun by chainstores and franchised bars and cafés, independent shop signs signify what is fast becoming a rarity in an overwhelmingly corporate society. Contemporary designers are increasingly fascinated by generic, everyday elements. 'Undesigned' typography found on bus tickets, receipts, road markings and so on, is valued as the purest form of representation, an indication of an economy of means, and related to basic human need. Even graffiti takes on a fresh appeal as the urban landscape becomes homogenised – surroundings dominated by mostly drab and unimaginative industrial or commercial buildings have bred a more colourful and flamboyant graffiti style [2], while cities such as Barcelona, filled with wildly imaginative architecture, seem to develop the dullest variations.

In the 1960s and 1970s, there were easily demonstrable links between contemporary typography and technology, but today type design is more influenced by cultural elements such as fashion and art. In addition, the boundaries between disciplines are breaking down and the public now also have a greater influence on design, having become more astute judges through their own daily experiences of living in an intensely consumerist society. Although they are still seduced by advertising, people now know when they are being tricked by Photoshop and are less convinced by low-quality content disguised with high levels of finish. Maybe as a result of this new cynicism, rough and ready graphics are increasingly favoured over slick, computer-generated design, as

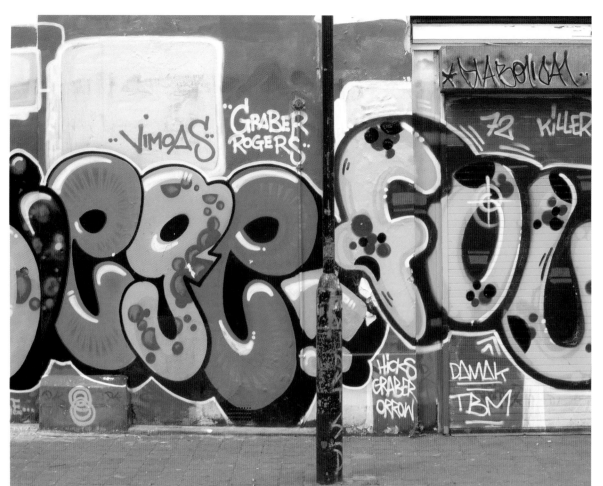

2. Above: Street graffiti,
Caledonian Road,
London 2002

3. Below: Advertising
billboard for the new
Toyota Corolla, London 2002

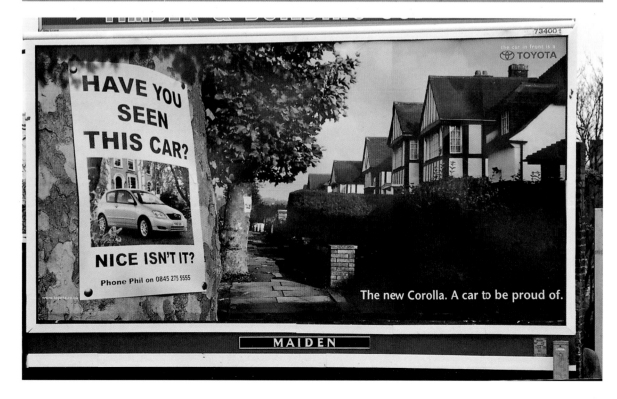

individuality and uniqueness become associated with the notion of trust [3]. 'There's a sense of believability about handmade graphics,' points out designer Henry White, who contrasts the work he produced at the advertising company BMP to the hand-painted shop signs and billboards of India, where he now lives.

Unsurprisingly, in a world increasingly hostile to the big brand, this notion of 'believability' is something the corporate world is increasingly focused on. Sony are currently working with design agency Tomato to find a way of replacing a monolithic, single-logo corporate identity with an artificial life-form residing on Sony's website, which is programmed to mutate constantly (http://www.sony.co.jp/en/SonyInfo/dream/ci/en), and Levi's are heading towards a more 'authentic' aesthetic by physically battering and spoiling the fabrics before turning them into clothing. The implications are worrying for those people struggling to voice oppositional messages and, more particularly, for those giving visual form to those messages – what will these statements look like when the visual vocabulary they adopt has been co-opted and rendered harmless?

Perhaps of greater concern is the fact that many larger companies are stealing ideas from genuinely creative individuals or small practices, encouraging their staff to sift through books or websites rather than source their own ideas. Such outfits have even been known to download a website and show it to a client, telling them 'it will be like this'. The commercial aim is to find specialists who can generate contemporary and fashionable design solutions, but ultimately to play safe by using ideas that have already been tested. Educational establishments – many of which are desperate for funding – are succumbing to corporate sponsorship with strings attached. The financial support that London's Central Saint Martins School of Art and Design receives from Diesel is repaid in kind by the college's graphics students, who spend part of their course coming up with new ideas for the company's billboard campaigns.

Design education has altered drastically since the keyboard replaced the drawing board. Staff invariably spend more time teaching digital programs as an easier alternative to teaching new ways of thinking, while students – apparently mesmerised by the magical powers of computers – are losing the ability to improvise. In 1997, New York-based graphic

designer and tutor Paul Elliman described how a surprising number of design institutions actually don't encourage students to speak their own words and think their own thoughts, although, as he points out, it sounds almost 'trite' to say that education is about the confidence to do so. Some courses are trying to deal with these issues by breaking down the boundaries between digital and non-digital methods. Andrew Whittle, graphic design course director at London's Central Saint Martins, explains that teaching is now heading towards integrating new and old forms of technology. One example of this is the revival of the Rostrum camera, which allows students to film their own drawn sources, collages and models, and then import them into web designs. Whittle says: 'Now that new media and information technology is so well established, I thought it was time to go back and encourage traditional animation again, and it has been very popular.'

The question of what should become of letterpress has been the focus of recent – and heated – debates in many design colleges. In 1999, students at the London College of Printing revolted against the proposed disposal of their letterpress department, delivering a statement addressed to the head of its governing body which read, 'we understand the urge to incorporate digital media, but we don't believe that computers can be a substitute for decades of human experience.' Similarly, at London's Royal College of Art, the letterpress unit would have been scrapped during the mid-1980s had it not been for the interference of some of its staff. Now the college is trying to incorporate digital technology into its letterpress courses, using the help and experience of the students well-versed in digital technology to adjudicate how the two technologies are integrated.

Contemporary graphic designers are in a more powerful position culturally than they have ever been, and have the broadest range of processes at their disposal. A growing number have been producing some of the most innovative work of recent years by making creative use of both past and present technology, or by avoiding the obvious route in the transformation of their ideas into physical form. These designers are gaining control of the computer's future by contributing their own ideas, encouraging technology to develop in a more imaginative, more human way. They are succeeding in stimulating their audience by attempting to reflect reality. The potential of this approach in terms of effective

communication is high, especially in today's increasingly uncertain cultural climate – advertisers and government bodies are already following suit. What this influence means for the future of graphic design is still hard to assess, but for now it is encouraging to observe that for more and more of today's practitioners, the drive behind their work is a search for concept, not style.

The examples in this book are divided into two categories – the first about non-digital methods of production, and the second about the ways in which analogue techniques are being used to generate ideas. The book feels like a starting point. It illustrates a handful of what is a rapidly growing body of ideas amongst graphic designers who are using combinations of different processes and materials. Perhaps a new technological revolution will again distract designers into focusing too heavily on the wrong thing, but it seems that at a time when many are finding the confidence to reject the computer as an exclusive design tool, the potential for new ideas is immense.

Analogue processes

PRINTING

Over time, printing has increasingly become a technology rather than a craft or trade. In the nineteenth century, technical developments within the industry meant that power-driven machines began to take over tasks traditionally carried out by craftsmen. Design standards also dropped as printers tried to outdo one another, exploiting emerging technologies to answer the needs of large firms who relied on printing to identify, describe and label their products in a newly competitive consumer marketplace. More recently, the relationship between design and printing has become particularly problematic. Since digitisation in the twentieth century, the gap between the role of the printer and the designer has widened, leaving designers with little understanding of how to achieve the results they want. The advent of television and computers has resulted in a visual language that is mainly virtual, with colours perceived in RGB instead of CMYK [p. 152]. Most young designers are hardly aware of the difference, and are often baffled when they find the colours they chose on the Macintosh coming back from the printer looking entirely different on paper.

Knowing how printed colours mix is essential to controlling outcomes, and makes possible the efficient use of colour in cases where a broad range can be achieved by overprinting a select few. Although software can now simulate the effects of overprinting, designers still have to imagine results as computers are unable to display on screen what actually happens on paper – they cannot provide an accurate prediction. Eric Kindel, tutor on the graphics course at Reading University, concluded that many designers might avoid colour printing because of 'the perennial difficulty of prediction, the scarcity of imaginative examples, the lack of clients and printers willing to countenance uncertainty and experimentation, or the configurations of present-day software applications that obscure the expressive potential of the printing process' [E Kindel 2002].

Notions of quality

Digitisation has also had a big effect on the quality of printed matter. The vast proportion of material is now litho-printed, and, for short runs, digital outputs (where toner is used instead of ink) are increasingly

YOU ASK FOR INCREDIBLE PLEASURE

1. Spread from *Private Act*
Design: Phil Baines,
London 2001
Baines wanted the scans for
this art catalogue for an exhibition
of the work of David Troostwyck
to have the same quality as the
original images, which were
reproduced at 60 dots per inch.
The image-setter he was using
was unable to scan at a low
enough resolution, so having
sent the images to be scanned
elsewhere, Baines dropped the
new film into the existing artwork.

used. The litho-print process has now attained such a high level of finish that the things it produces can appear bland and characterless; and digital outputs can look monotonous, restricted by the set of colours and limited paper stock available. 'There is a tendency for printers to scan very well, but sometimes you want roughness,' says Phil Baines, designer and tutor at London's Central Saint Martins [1]. Baines scans his own images for certain jobs because it is the only way he can achieve the low resolution he sometimes wants. Even back in the 1960s, Dutch designer Willem Sandberg's dislike of the development towards perfectionism in print prompted him to coin the term 'warm printing' as a way of distinguishing his work from what he saw as the antithesis of 'cold printing', a description others applied to the Swiss style emerging at the same time.

Digitisation has meant that professional levels of reproduction can be quickly and easily achieved, but it has also made the notion of quality in design more ambiguous. Design criticism today seems to be more about people's perceptions than about standards, often focusing on the designer's status rather than the work itself. But regardless of questions of the quality of individual designs, it seems unlikely that digital reproduction will ever match the immense subtleties of tone and resolution that analogue imagery can contain. Some graphic designers are beginning to accept that they need to readdress their understanding of print technology in order to achieve more variety in and more control over their work.

One of the problems is that computers and their software need to evolve significantly before they can fully aid this kind of move. Massachusetts-based Nicholas Negroponte, co-author of *Maeda @ Media*, complains that software is evolving as 'a compost heap of useless options, expired releases and nonsensical interfaces, making computers harder to read and increasingly less reliable' [J Maeda and N Negroponte 2000]. As far as Negroponte is concerned, the practice of digital art and design will inevitably have difficulty in moving forward while its virtual tools are designed merely to emulate existing tools, and while it still uses terminology derived from pre-digital processes.

22

Retreating

One solution to this creative problem has been for designers to start exploring more traditional forms of communication. During her MA at the Royal College of Art in London, first year graphics student Kirsty Carter decided to do exactly that, having spent most of her previous degree course working with digital media. She concluded that, compared to the discipline of traditional print, digital media requires advanced technical understanding that actually inhibits its use, mainly because the medium is so young and people are still not sure how to use it [p. 50].

Carter is not alone in this kind of thinking. In 1999, design writer Michael Worthington remarked that, 'print is undergoing an extraordinary renaissance in which it celebrates materiality, flexibility and desirability – areas in which screen-based design cannot compete' [M Worthington 1999].

Letterpress

An obvious indication of this revival is that letterpress has become fashionable. Despite being slow, labour-intensive and costly in comparison to modern printing methods, an increasing number of designers (and often, their clients) want to use it. Partly this is because the process offers so much more than the computer in terms of learning about print. Ex-Pentagram partner Michael Bierut has suggested that, 'to understand how type got to be that way and use it well in that tradition, or to flout convention and release type from the form to develop it in new ways, the start point is an understanding of the process and history of letterpress.' Given that computer programs are still based on systems in which type is 'set' within rectangular bodies held in invisible frames, and that they use terms derived from pre-digital processes such as 'upper and lower case', 'baseline' and 'leading', Bierut's point seems a valid one.

There are other reasons for this resurgence in the use of traditional printing methods. The main attraction is tactility, which computers cannot yet simulate. Having grown so accustomed to the monotonous 'flatness' of litho-printing, designers are increasingly attracted to the uneven, textured surface inherent to letterpress.

2. Printed record
Design: Ben Chatfield, London 2001
Chatfield bought some old records from a second-hand music store, then took them to a letterpress room where he inked them up and printed directly from each one onto various coloured papers. The result is an exact reproduction of every scratch and mark, illustrating the degree of wear and tear on each track of the original record.

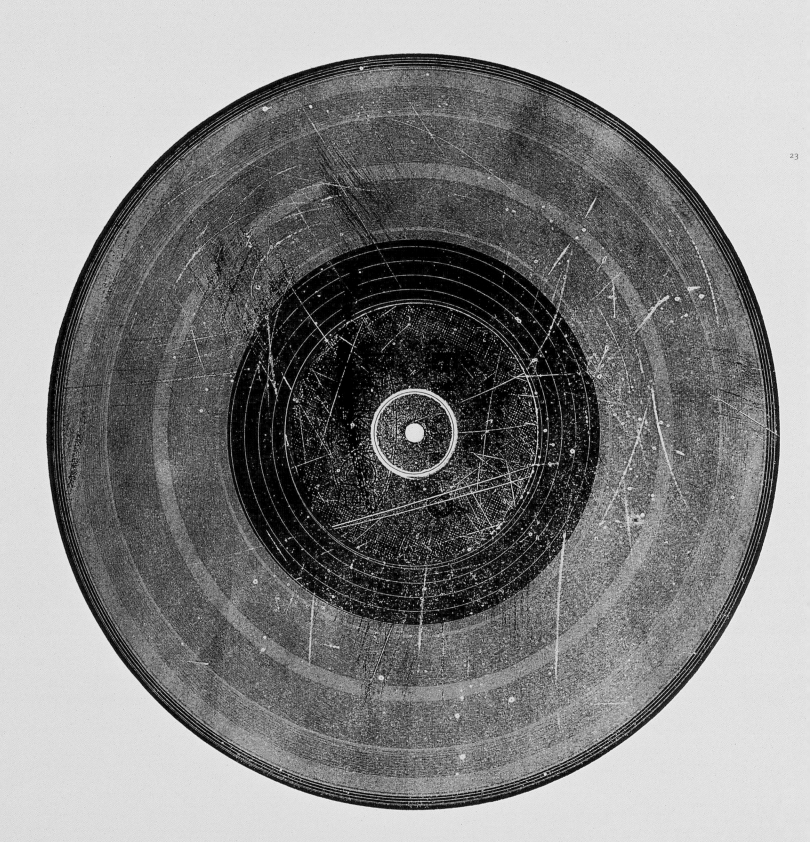

24 Physical involvement with a process that produces work with
distinctive qualities of weight, texture and smell also creates an
opportunity for creative and inventive thinking that, effectively,
working in front of a screen removes. Designers are forced to
conceptualise pictorial space by setting type in reverse, which
encourages them to consider a wider range of options before deciding
on a solution; while on-screen, they usually work from left to right
because this is closer to the process of reading. Added to this,
letterpress technology has become rare, which makes it special
almost by default – the growth in the use of computers resulted in
hundreds of presses being discarded as they were unable to compete
with new production methods. As is often the case, interest is only
generated when a discipline is almost completely wiped out.

Occasionally, letterpress is used as a means of achieving
superior quality in print. 'We used to order letterpress for headings –
for finer, better-quality type – and set the rest digitally,' says John
Morgan, who worked with Derek Birdsall at Birdsall's London-based
design company, Omnific. But the overriding fashion is for poorly
printed blocks of type: either done softly enough to show the wooden
texture of the character, or so forcefully that the paper is physically
debossed. This usually comes down to lack of training, but even
professionals such as London-based Alan Kitching have been known
to deliberately 'print badly' [3], suggesting that for today's design
practitioners, it is often the imperfections of letterpress in particular
that make the method so appealing. Kitching's recent work engages
predominantly with an exploration of the artistic potential of
letterpress, bearing a closer resemblance to illustration than it does
to graphic design. For Kitching, this has become a way of relinquishing
the responsibilities of producing 'quality', which he feels is a redundant
imperative now it can so easily be achieved using computers [p. 52].

For most graphic designers however, letterpress is unrealistic for
use as part of their commercial work because it is expensive and takes
a long time to do. Due to a lack of competition, letterpress firms have
been able to raise their prices, while the increasing demand for the
services of what until recently was a dying industry has led to a sense
of élitism – for example, Forme Press (in the UK) will charge as much

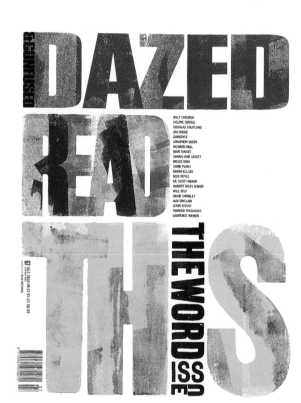

**3. Magazine cover
Design: Alan Kitching,
London 2000**
Dazed & Confused art director
Martin Bell commissioned Alan
Kitching to design this cover for
the magazine's 'Word issue'.
'We wanted to get away from our
stereotypical cover, which is a
big portrait on the front of a
celebrity or model,' Bell explains
– he specifically wanted to use
a traditional technique.

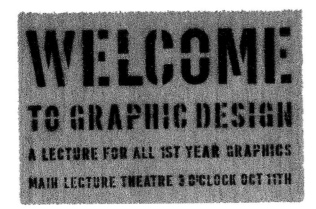

4. Lecture poster
Design: Johnson Banks,
London 1995
Johnson Banks used
screenprinting as a means of
reproducing information about
a graphic design lecture
at Kingston University on a
domestic doormat.

as £100 per word. New York designer Stephen Byram describes letterpress as 'a kind of boutiquey thing' [S Byram in J L Walters 2002]. The extra effort and expense involved in using a process that is no longer accepted as standard also means that a designer makes some kind of statement in choosing it, which may or may not be appropriate to the job. London-based Vince Frost realised this before redesigning the *Independent on Saturday* magazine in 1995. Frost considered using letterpress but then abandoned the idea, realising it would seem old-fashioned or twee. His catalogues for the publishing company, Fourth Estate, provided a more suitable opportunity [p. 54].

Screenprinting

Graphic designers have been using other methods to gain an understanding of the print process, and to introduce more variety into their work. Like letterpress, screenprinting has generally been replaced by digital processes and, as a result, has become an increasingly expensive trade. But screenprinting is still the best way to print onto unusual surfaces [4], to achieve the most vibrant colours or to print using white ink. And the slightly raised areas that are left where the ink remains provide a tactile surface that designers often want to exploit.

Artomatic

Screenprinting is one of the services offered by Artomatic, originally launched in London in 1984 as a print production service for graphic designers. Partner Daniel Mason explains that the company, 'allows designers to have a means of self-expression. We let them screenprint with us for nothing in the hope that it will motivate them to do something for themselves.' Designers first have to agree to buy a certain amount of print through the company, but Mason argues that customers are paying for quality. 'The printing industry is so open to service that they'll just take anything and do it really badly,' he says. Artomatic recently set up a second branch in East London that includes a library that offers a collection of samples, materials and processes to members in the hope that they will become aware of 'a spectrum of print processes, utilising a wide variety of →

5. Left: Preliminary
artwork for Italo Calvino
book cover (detail)
**Design: Susanna Edwards,
London 2001**
Edwards created this image
by printing letterpress onto
gauze. She then overprinted
the single layer of gauze in the
darkroom to make a photogram.

6. *Ambit* magazine cover
**Design: John Morgan,
London 2002**
The title on this cover is
reproduced using Letraset,
once a standard means of
reproducing type. Morgan had
to use this technique as he
could find no digital version
of the particular version of
Egyptian Bold he wanted.

7. Invitation for **APC**
fashion show
**Design: Rik Bas Backer,
Paris 2002**
The type was hand-drawn then
embossed onto a metal plate
that was used to print from. This
technique was one of the first
to replace iron-cast fonts and
is now rarely used except for
traditional printing jobs such as
wedding invitations. The empty
rectangle is for the guest's name
to be written in by hand.

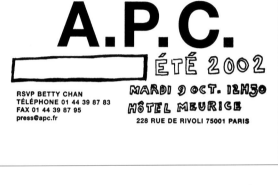

8. Paradiso Club CD
**Design: goodwill,
Amsterdam 2001**
For his limited-edition CD,
goodwill used a stencil as a quick
yet personal means of executing
the covers on each of the fifty
copies. The marker pen he used
was deliberately intended to show
through onto the reverse, creating
a different 'map' for each CD.

9. Slide projection
**Design: Manuela Wyss,
Zurich 1997**
These images are made by
photocopying an original
photograph, then making
subsequent copies from this
photocopy, enlarging or reducing
the scale each time. Wyss used
the images to make a slide show
that used three projectors,
allowing each slide to fade
slowly into the next, thus forming
a visual representation of the
photocopying process.

10. Typewriter diary (detail)
**Design: Ben Chatfield and
Jon Sarsfield, London 2002**
As part of a one-day project,
Chatfield and Sarsfield took a
typewriter to various parts of
London so they could use it to
record events they witnessed
at particular places: on the tube,
in their studio and in an accident
and emergency department.
Chatfield explains that the
typewriter suited the project
because it meant each entry
was a one-off that could never
be replicated.

→ materials'. The idea is that designers come with notional ideas of what they want and that Artomatic then decode those ideas, showing them examples from the library. The costs are invariably too high for most potential clients, some of whom also disapprove of this set-up's potential to allow competitors to pinch ideas. Not surprisingly, establishments like Artomatic are more common in the US where design budgets tend to be significantly higher.

Other non-digital printing methods

In the last few years, graphic designers have been discovering, or rediscovering, scores of other non-digital printing methods, apparently as part of a rejection of the computer processes they were previously so attached to. Letraset, etching, stencilling and photography have been reappearing in their work, while the photocopier, fax machine and typewriter have re-emerged as popular image-making tools [6–10]. Designers first became interested in using photocopiers during the Punk era in the 1970s. The rough and quickly-thrown-together results produced by photocopying were ideal as a means of representing the industrial and social decay that Punk wanted to expose. Today these machines are being used in much the same way, either as a way of contrasting slick, four-colour litho-printing or just as a cheap and simple means of reproduction [11].

Exposing the process

This revival of earlier forms of printing is not simply a renaissance. Most contemporary designers who use these processes are not doing so in order to imitate an earlier period, or to create a pastiche. Rather, they are adapting them within a modern context, experimenting with unconventional techniques and deliberately exposing the process of fabrication. Designers are recognising that some people feel more comfortable knowing how something is made; and it is easier to visualise the print process when it uses analogue as opposed to digital methods. Evidently this is beneficial for the designer, but it is less obvious why consumers of design value this purely visual understanding. Maybe it is partly related to people's experience of digital printing, known for its ability to

**11. 'Little Stars' booklet
Design: Jason Godfrey,
Austin, Texas 2000**
Godfrey produced this small-format booklet using a blue, red, black photocopier. He sent each page through the machine three times for each of the three colours, exploiting the fact that it was impossible to achieve accurate registration. The booklets are printed onto newspaper stock.

12. CD packaging
Design: A2-GRAPHICS/
SW/HK, London 2001
A2-GRAPHICS/SW/HK
produced an edition of 100 CDs for
their 'Interactive colouring book'
CD-ROM. The project focuses on
how colours are named by the
large companies that supply them,
so A2 decided to print the covers
by dipping them into various pots
of Dulux paint. The covers are
made out of card; the designers
left an extra inch at the open edge
to hold on to during dipping – this
was then trimmed off once the
card was dry. The name of each
CD-ROM is derived from that of
the Dulux selection (the one above
is called 'Playtime').

convince us by employing what seems a professional level of finish.
Analogue processes appear to be associated with the notion of
trust – although this will possibly change if advertisers and even
politicians continue to deploy them in their campaigns. These methods
also suggest that time and effort have been invested to a degree that
digital printing does not need to, so an item that has been created
using this kind of print becomes more precious. Whatever the reason,
the dismissal of certain techniques and processes no longer seems
as inevitable as it once did.

30

DRAWING

Just as the calculator has, if people choose, become a substitute for the ability to do mental arithmetic, so computers have replaced some of the designer's most basic drawing skills. Drawing used to be an integral part of design practice because a client presentation inevitably required it as a way of 'mocking up' a piece of print. Evidence of craft skills was considered to be essential – it added a certain quality that clients would respect. Today, design proposals may appear more professional but they have the distinct disadvantage of looking too finished at an early stage. Designers can consequently be reluctant to make changes or amendments to their initial ideas, and clients are put off by something that looks complete before they have got involved.

Practical advantages

There are practical reasons why drawing by hand is still relied upon by contemporary designers. Some of them argue that drawing with a mouse has now become as subliminal to them as using a brush or pen: 'the medium is better and faster for manipulation, and now cheaper,' says illustrator Nick Higgins [A Hyland 2001] – but for most, sketching on paper is still the fastest and most spontaneous way of creating an image. For his type designs, Phil Baines makes physical drawings before moving onto the screen; 'not for any purist reasons' he emphasises, 'just because it's faster' [p. 64]. Advertising designers have remained the most consistent advocates of drawing. 'They have to work more quickly than other designers,' describes Henry White, who worked as art director at advertising agency BMP. 'There isn't the time to sit at a Mac. The only way to do it is with a magic marker pen.' Two years ago, BMP launched a website that included the original art director's sketches – or 'scamps' – shown next to the finished adverts. 'I think they're objects of beauty themselves,' says White, 'in a way they're much nicer than the real ads.'

Visual expression

The idea of using pure, freehand drawing in their final work is something most graphic designers are surprisingly intimidated by. London-based Alan Fletcher describes how, when he first started designing in the

13. Film poster
Design: Stasys Eidrigevičius, Warsaw 1988
14. Theatre poster
Design: Andrzej Pągowski, Warsaw 1988
15. Theatre poster
Design: Andrzej Pągowski, Warsaw [date unknown]
16. Theatre poster
Design: Andrzej Pągowski, Warsaw 1983
The split between graphic designers and artists in Poland has always been less pronounced than in the rest of Europe. These posters are all hand-drawn, with the exception of 14, where the photocopied image is so distorted it still appears to have been done by hand. The images have been carefully executed, but the text often looks as though it has been added quickly at the last minute, giving the posters a fresh, confident feel. The type doesn't have to be big because the image does the work; text and image are well integrated because they are all drawn using the same method.

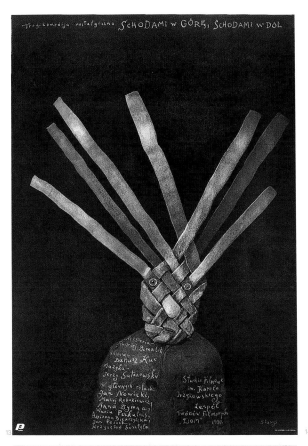

Tragikomedija nostalgiczna SCHODAMI w GÓRĘ, SCHODAMI w DÓŁ

Zapiski więzienne Stefana Kardynała Wyszyńskiego · Teatr Ochoty w Warszawie
adaptacja i reżyseria Jan Machulski · prapremiera 1988

Teatr Dramatyczny im. Jerzego Szaniawskiego w Wałbrzychu
Ludmiła Pietruszewska

NASZ SKŁAD

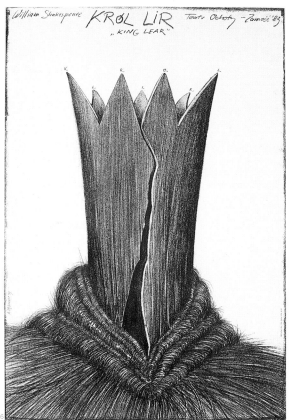

William Shakespeare KRÓL LIR Teatr Ochoty – Zamość '85
"KING LEAR"

1950s, for years he felt inhibited about directly expressing his ideas in this way. 'Those who were less skilled in drawing tended to take refuge in typography, persuading themselves it was a more worthy activity than illustration,' he explains [A Fletcher and J Myerson 1996]. In Poland, the split between graphic design and art has always been less distinct than elsewhere, so designers there have been less reluctant to use drawing in their work. The posters by 'graphic artists' such as Andrzej Pagowski and Stasys Eidrigevićius are widely regarded as being amongst the most powerful and evocative of the last century. The curious, mythical images are executed with such confidence that it is enough for the type – always beautifully integrated with the whole – to sit discreetly at the edge [13–16]. Few contemporary graphic designers would have the confidence to work in such a raw, unaided manner.

Effects of digitisation

Digitisation has also discouraged the use of drawing in graphic design. Many designers still argue that it can never be a valid substitute. 'You can imagine anything you like and put it in a computer, but it will never have the perfection of the hand-drawn image or the freedom which I value so much. I don't like the square, aggressive teeth of the computer screen,' describes Polish designer Roman Cieslewicz [R Cieslewicz 1993]. Ultimately, one of the drawbacks of digital processes is in the freedom they offer – they can prove as disabling as they are liberating. Designers, unlike artists, need parameters. For Alan Fletcher, design is literally a matter of self-discipline, best tackled by forcing oneself into a tight corner. He often limits himself to simple tools such as a marker pen, a biro, or even the wrong end of a dip pen [17]. However, for Fletcher, the computer is no different from any other tool, and should be treated accordingly: 'It's just a complicated pencil.' But the lack of physical engagement is a hindrance. The use of the computer's virtual functions denies designers the opportunity to retain the image in their imagination or to visualise an outcome, encouraging reliance upon the prescribed routes that have been conceived by the program's creators. Because of this, some designers are now going back to analogue methods

17. 'Night on the Tiles' poster (detail)
Design: Alan Fletcher, London
The cats are freely drawn in ink using the wrong end of a wooden dip pen.

This card was designed for a
screening of artists' videos
for the Stedelijk Museum's
Lost & Found exhibition series.
Armand Mevis traced all
the previous *Lost & Found*
invitation cards using a blue
ballpoint pen, then overprinted
the information for the evening
at the Stedelijk in black.

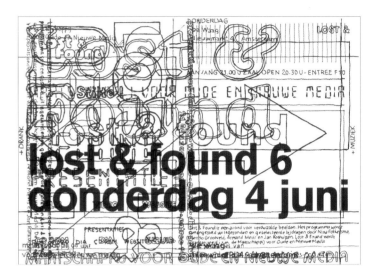

**18. Above: Newsletter for
Stedelijk Museum Bureau
Design: Mevis & van
Deursen, Amsterdam 1998**
The designers used a black
marker to draw the cover of this
newsletter (which they still
design each month), including
the logo and address details that
usually appear unaltered on
every issue.

**19. Page from *Mono*
magazine
Design: David Pearson,
London 2002**
Pearson deliberately avoided
using the computer in producing
Mono, making a statement
against the multitude of high-
gloss fashion magazines.
'The theme was fundamentally
"do-it-yourself",' he explains,
'there would be no seductive
gaze to draw you in. There would
be no fantasy world in which the
viewer could escape.'

where the whole nature of the process is fixed, where decisions have
to be considered, and where experiments have a direct impact on
people's understanding of the design process.

Hand-drawn typography

Designers are increasingly experimenting with hand-drawing as a
means of introducing another layer to their work. Most are still reluctant
to draw images from scratch, so instead they are incorporating hand-
drawn type or lettering into their designs. As Dutch designers Mevis &
van Deursen describe, 'we began to feel the urge to draw type by hand
a few years ago to give it another kind of sensibility, almost as a reaction
to design which was celebrating Seventies modernism/Swiss type
again and the computer-generated language of designers like Tomato
and Designers Republic.' [18 and 20] David Pearson, currently studying
at Central Saint Martins, belongs to a group of young designers who
are simply growing tired of turning to the computer as the solution
in all projects. 'We became visibly rejuvenated at the very thought
of dropping it entirely,' he says – which is how his hand-rendered
magazine *Mono* came about [19].

For years, people have tended to be put off by anything hand-
drawn because it looks crude in comparison to anything digitally
reproduced, but most have retained a kind of affinity with this form

Mardale Ill Bell 9

RIDGE ROUTES

To HIGH STREET, 2718': 4/5 mile : WNW then NW
Depression at 2350': 400 feet of ascent
An easy walk with interesting views

A sketchy path leaves the summit but is of little consequence; i
is preferable to follow the edge of the escarpment after crossin
the depression. At one point, marked
by a cairn, there is a sensational
downward view of Blea Water. In
mist, incline west to the wall.

To THORNTHWAITE CRAG, 2569'
1⅓ miles : WNW, then WSW, W & NW
Depressions at 2350' and 2475'
250 feet of ascent

Easy walking, confusing in mist
When the short turf gives place
to rough grass, keep the
rising slope on
the right hand
and climb very
slightly (do not
descend to left).
A track will be
found as the end
of the wall comes
into sight.

HIGH STREET
Ordnance Survey column
2700
2600
grass
2500
Blea Water
THORNTHWAITE
CRAG
line of old fence
2500
2400
2300
N
MARDALE
ILL BELL
2400
ONE MILE

To HARTER FELL, 2539': 1 mile : SE. then ESE and E
Depression at 2100' (Nan Bield Pass): 500 feet of ascent

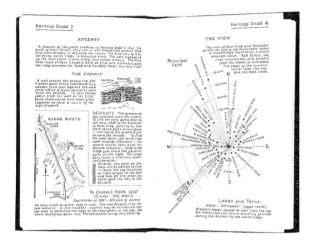

**21. *The Far Eastern Fells*
(spread and detail)
Design: Alfred Wainwright,
Kendal, England 1957**

Wainwright researched, wrote
and hand-drew every edition of
this series of seven publications
all from his own desk, like a
modern desktop publisher.
By using the same pen to
execute both the drawings and
type he achieved their perfect
integration. The justified text

setting meant that Wainwright
had to draw each layout twice in
order to work out the exact width
and kerning of letters. If he made
a mistake, he screwed up the
page and started again. 'I am
stubbornly resolved that this
must be a single-handed effort,'
wrote Wainwright, who refused
to accept input from anyone else.
Over a million copies of the
books have been printed since
the first edition in 1956.

of image-making. The popularity of Alfred Wainwright's entirely hand-rendered pictorial guides to the Lakeland Fells proves this well, having sold over a million copies since it was first published in Kendal, North England in 1956 [21]. And in general, drawing has also been gaining respect, as people have grown increasingly accustomed to the 'look' of digitisation. Drawing implies something that is genuine and that can be trusted, and it also stands out against the flatness of computer-generated material. Most people are now aware that any unskilled individual can produce a professional-looking 'drawing' by relying on the special effects of a computer program, whereas something hand-drawn depends on an individual's creative ability – interestingly, the editors of *Viewpoint* think it is now the only way of making their product stand out against other magazines [p. 112].

22. Below: Poem poster/book
Design: Stuart Bailey,
Amsterdam 2001
Bailey arranged the words in an
apparently meaningless way over
both sides of an A0 sheet of paper
using a photocopier. The idea was
to produce a poster that folded
into an unbound booklet, in which
the words could then be read in
the correct order.

25. Opposite: 'The Monster
Story' (detail)
Design: Sam Winston,
London 2001
After fifteen attempts at trying
to write a piece about monsters,
Winston decided to cut up each
draft and turn them into a book.
He describes how the visuals
attempt to capture the frustration
and awkwardness that, being a
dyslexic, he sometimes feels
when he has to write something.

36

PAPER WORK

The biggest drawback of computers in their current form is their
lack of physicality. The only form of 'feedback' they can offer is
on-screen or in a print-out. Objects cannot be physically picked
up and moved around and there is a restricted sense of scale –
everything has to fit into a small window. Not only does this
dissuade designers from experimenting with materials but, more
seriously, it impedes the process of translating their graphic work
into the physical realm. This is a real problem in education where,
to avoid running up vast bills, students often print pages only after
they have completed their layouts – for example, at Central Saint
Martins, each laser-copy is monitored electronically and charged
to an individual account. One outcome of this is that students
regularly forget to include margins in their layouts – as they never
hold the page in their hand, it never occurs to them that space
should be left for them.

Page impositioning

There is a similar constraint with page layout. Page impositioning
has become an automatic feature of computer programs, so
designers generally work on pages in the sequence that they will
ultimately appear; as it is now the printing company's responsibility,
designers hardly have to think about it. On the one hand, this
relieves them of a laborious and time-consuming task, but on the
other, it inhibits both understanding and creativity. And it is only
by working without the aid of a computer that designers can come
up with design solutions that involve less conventional folding
methods [22–3]. For Derek Birdsall, cutting, photocopying,
positioning and pasting are an essential part of the design process.
He cannot conceive how a computer would generate for him the
same sense of satisfaction, or provide such creative freedom.
Birdsall argues that it is far harder to discard a finished-looking
computer-written document than it is a sketched piece of paper,
even if equal time is invested in both – he also claims that the various
systems he has developed enable him to work as quickly as any
keyboard operator [p. 68].

23. Right: Poster/brochure
Design: Peter Brawne,
London 1998
The poster details are printed
on one side and the leaflet
information on the other. By
cutting a slit into each sheet, the
pages can be folded in such a way
that they work as both an 8-page
A6 leaflet and as a flat A3 poster.

24. Below: Museum catalogue
Design: Willem Sandberg,
Amsterdam 1961
Sandberg carried the theme of torn
paper shapes right through this
catalogue, starting with the cover
[left] which is printed in a single
colour onto rough-textured paper.
Some of the text pages are printed
onto tracing paper, allowing
Sandberg's abstract images to be
revealed underneath [right].

"If "I "If
"I "If "I "If

you

you you
you you
you you you
you you you
you you,
you you you, you you
you You you, you you
you you You You you you
you you, you
into into
into into

with with
to get get into

to get get into
to to
to my my my
to to to my my
to my my my
to to to my my my
to to to my my
to to my

Image-making with paper

Another drawback of relying on computers is that it discourages graphic designers from physically using paper as part of image-making. The potential of this device is particularly well documented in the work of Willem Sandberg [24], which follows an approach first introduced by the Dadaists in the 1920s. For Sandberg, tearing paper became an alternative to drawing – he liked the fact that is was harder to control, so appearing more spontaneous. However carefully Sandberg tore each piece, it would never turn out exactly as he planned, even when he occasionally perforated the outlines with a pin so the shapes would not appear too casual. In reproducing them for print, he used to place the paper forms straight on a metal offset plate and light them directly, so allowing the structure of the paper to be an integral part of the work. The layering of information and the use of tracing paper to create blurring effects is surprisingly reminiscent of the postmodern graphic design style of the 1980s and 1990s – but while the Macintosh simulated layers that consisted only of a smooth, flat surface, Sandberg's tracing paper could be lifted to reveal a different kind of image underneath.

Paper availability

Design that looks something like Sandberg's work is appearing more and more as designers strive to escape the 'Mac-look' [25–7]; this in turn is affecting wider developments in the industry. The rapid growth of the graphic design community over the last two or three decades has led to a huge rise in the range of papers available. Printers and manufacturers are becoming more accommodating as the range of demands grows, and technology is becoming increasingly compatible with the new materials [28]. A change in taste in paper stock is reflecting the general move away from the smooth and the slick, and itself encourages the use of non-digital processes. In the 1980s, pure white, chemically enhanced, ultra-bright stock was all the rage; today, uncoated or handmade papers and boards have become enormously fashionable among contemporary graphic designers. For Adrian Shaughnessy, creative director at London's graphic design company Intro, the current trend represents 'an important signifier of integrity in a world where the synthetic and the simulated are overwhelmingly prevalent' [A Shaughnessy 2001].

**26. Concert flyer
Design: goodwill,
Amsterdam 2002**
goodwill cut out and pasted the text into position, having found he could not achieve the effect he wanted using a computer. The shape is taken from the broken marble altar of the church where the concert was held. (The altar was once heated for several hours to make things more comfortable for a model who was sitting on it whilst being painted – some weeks later a great piece broke off and, too heavy to be lifted, has remained where it fell ever since.)

**27. Molecules CD cover
Design: John Morgan,
London 1997**
Morgan took a square piece of paper the same size as the sleeve box of a CD, tore it into pieces, then scanned the pieces to create the final cover image.

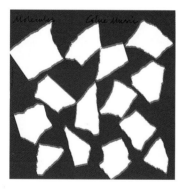

**28. Rolling Stones CD cover
Design: Stefan Sagmeister,
New York 1997**
The inspiration for this cover came while Sagmeister was staying in a London hotel at the band's expense – they had forbidden him to leave until a cover design had been agreed upon. The hotel was old and full of paper doilies and pot pourri. Taking handfuls of these, some examples of Babylonian imagery collected from the British Museum and a mass of background patterns faxed from his studio in New York, Sagmeister set to work with scalpel and spray mount until he came up with this solution.

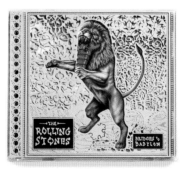

**29. Marc Ducret CD cover
Design: Stephen Byram,
New York 1999**
Byram uses uncoated boards
for much of his work on CDs as
a means of distinguishing his
designs from those used for the
standard perspex-format cases.

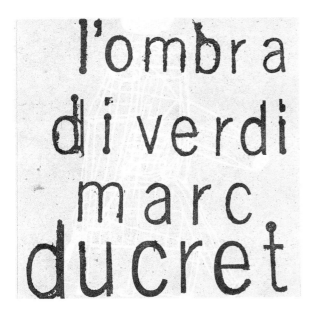

Uncoated paper

39

As a material, uncoated paper feels natural, warm and tactile. Its imperfections give it an organic quality that fits in well with an age so concerned with preserving the environment (even though this paper is actually often no 'purer' than coated stocks). The absorbing and softening effect uncoated paper has on colours offers a relief from the garish palettes associated so strongly with advertising. Uncoated papers are becoming particularly popular in the record industry with small labels who are not forced by manufacturers to comply with the standard and restrictive CD perspex 'jewel' case [29]. Adrian Shaughnessy suggests that these materials themselves and the apparent 'realness' of the kind of image that can be conveyed when they are used represents a hint of authenticity in the 'cosmetically manicured' world of pop. 'Uncoated board becomes the equivalent of two fingers held up at the record industry; a statement that says: we're not part of your hardball game, we play different rules' [A Shaughnessy 2001].

Digital changes

Computers are already providing more scope for using these materials, but it is hard to imagine how as a technology they will overcome the problem of a lack of physicality. Undoubtedly the current interface will change – there have already been discussions about the way paper-like interfaces will one day replace the now standard screen, keyboard and mouse. But the sense of scale and the real sense of working with something physical can never feasibly be simulated through digital technology. It seems that if graphic design is to exploit the full potential of paper, there is no alternative but to work directly with the material itself.

Analogue and digital

30. 'City Stilts' and 'Stilts'
Design: Peter Anderson,
Gravitaz, London 1994
The images were designed
to be used as pieces of art at
London's Hamilton's Gallery, as
well as to work as functioning
graphics in various magazines.
Anderson created the text on
a computer, printed it from his
laser-copier, then placed

it face down onto another
sheet of paper. He then covered
the reverse with lighter fuel
and rubbed it with his hands
so the type was transferred
onto the second sheet, thus
resembling letterpress [p. 90].
Anderson re-scanned the
type, coloured it, and finally
combined it with the images
in Photoshop.

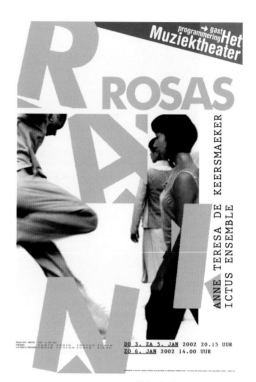

40

TECHNOLOGY

Graphic Thought Facility's Huw Morgan thinks there is currently something in the air that is encouraging digital design to be mixed with other processes. 'The new generation of young designers are realising that everything comes out of the computer looking very clean. Even if it's raw, it's clean, so they are beginning to move towards other processes,' he explains. For Morgan, design is very much about contrasts, and the combination of digital and hand-generated graphics is a way of achieving the most obvious antithesis.

Peter Anderson

Peter Anderson, who has his own company in London, has a fascination with language and technology that has led to some highly complex integrations of digital and handmade processes. Anderson often incorporates his own words into designs that he creates either by hand or digitally. 'I'm fascinated by the idea that we can now type letters into a machine and physically create something new. Written language has reached that next stage of being alive', says Anderson [C Foges 2001]. His typically organic fusions of words and images stem partly from what Anderson recognises as a growing desire for the natural in our increasingly manmade environment. Many of his images go through numerous production stages, involving techniques that include photography, etching, Letraset, stencilling, screenprinting, computer typesetting, drawing and colouring [30]. When he is unable to do everything himself, Anderson works closely with technicians on the reproduction side, pushing the boundaries to discover techniques that sometimes had not been thought possible [p. 78].

Transformation through computers

Computers have transformed graphic design. They offer both flexibility and speed, enabling more control over the pre-print process than ever before. Designers no longer have to depend on unwieldy specification systems and the involvement of other individuals working between them and the printer. Typographically, computers are able to do things that would previously have been inconceivable: characters can be kerned indefinitely, type can be set to within a fraction of a point,

31. Poster for
'Gastprogrammering Het
Muziektheater'
Design: Mevis & van
Deursen, Amsterdam 2002
The poster announces the
Belgian dance group, Rosas, who
were performing in Amsterdam.
The big letters 'R-A-I-N' were first
printed out at a small scale then
enlarged using a photocopier,
then scanned so they became
rougher than regular type. The
type appears slightly translucent
due to the small white spots that
came from the photocopy. 'It's
really subtle,' says Mevis, 'but for
us it gives the poster another feel,
and it influences the decision-
making in the design because the
type literally becomes an image.'

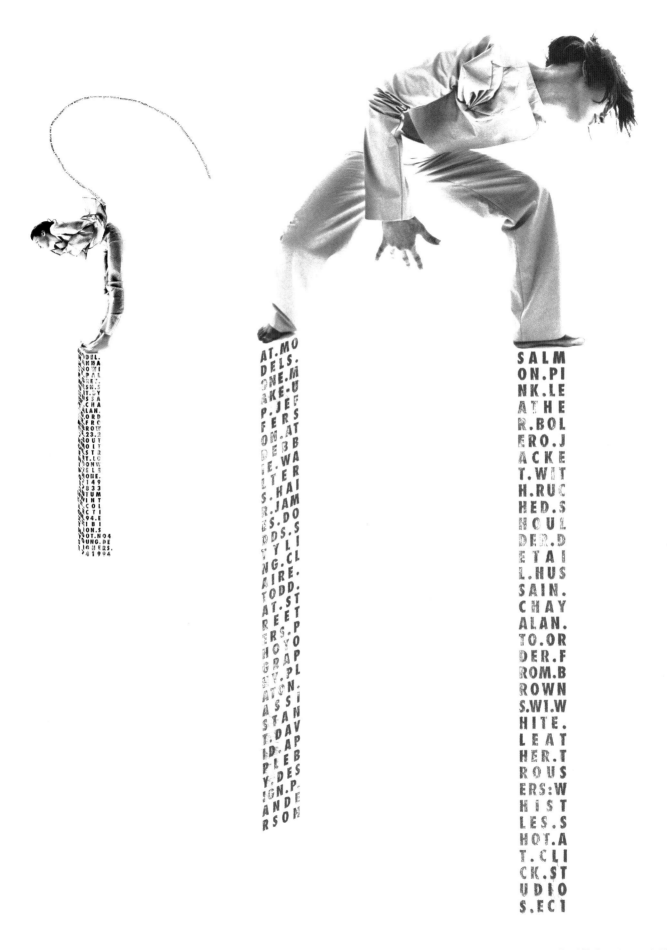

MODEL.ANNA.WILMA.SUIT.BY.ALAN.SHAW.CHAN.ORDER.FROM.23.OUTFIT.LONDON.WE.ONE.149.833.UNICOTE.94.E.RIBION.SHOT.NO4.YOUNG.DESIGNERS.41994

AT.MODELS.ONE.MAKE-UP.JEFFERSON.AT.DEBTERS.WALTER.HAIRES.DONGDS.STYLING.CLAIRE.TODD.AT.STREET.HOTHOGRAPHY.PLATON.ASSISTANT.DAVID.APPLEBY.DESIGN.P.ANDERSON

SALMON.PINK.LEATHER.BOLERO.JACKET.WITH.RUCHED.SHOULDER.DETAIL.HUSSAIN.CHAYALAN.TO.ORDER.FROM.BROWNS.WI.WHITE.LEATHER.TROUSERS:WHISTLES.SHOT.AT.CLICK.STUDIOS.ECT

42 and shapes and sizes of letterforms can be adjusted with absolute freedom [31]. The same applies to image manipulation, where colours, forms, textures and special effects can be endlessly applied and altered, no longer constrained by the build-up of bulky materials.

But computers are not just seductively useful – they are a necessity. Almost everything has to go through a computer at some stage, as designs need to be put into a format that printers and producers are used to receiving. Yet regardless of this, the computer is no more conducive to creativity than other processes. 'The computer does nothing for you. It only makes things a lot easier,' describes Pepijn Zurburg from the Dutch company Design Politie. What makes sense is to combine it with processes that are more familiar and better understood. New York-based Stephen Byram explains how it was impossible not to be afraid of computers when they first came on the market because they were so expensive, but he now thinks they allow for enormous creativity providing they are regarded as a tool, not as the source of inspiration [p. 76].

Understanding production

Designers commonly emphasise the importance of understanding the tools they use, but, being so complex, computers tend to disallow a complete understanding of the range of their capabilities. Dutch type designers Eric van Blokland and Just van Rossum are amongst the few who intervene in the realm beyond pre-programmed interfaces by manipulating the software to their own specific requirements, giving themselves a greater control over their work [p. 85]. But even designers who have explored the full potential of computers are beginning to see their limitations. Amsterdam-based designer 'goodwill' describes himself as a 'former computer whizz', but says he reached a point where he could get no further solely with computers. As a result, goodwill is now finding ways to incorporate analogue-based elements into his work, including drawing, cutting and pasting, and even, on rare occasions, sewing.

Other designers are also opting to use non-computer-based, simpler processes that give them a clearer understanding of the production process. Graphic Thought Facility are typically attracted

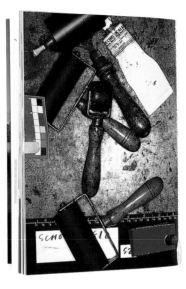

32. Prospectus for LCP Design: Graphic Thought Facility, London 2001
To create the images in this prospectus for the London College of Printing, Graphic Thought Facility built a camera that resembled 'a moveable coffee stand'. Regardless of distance from the subject, all images were created by framing the view through the same square 'hole'. This restrictive, low-tech method created a visual democracy (nothing could be zoomed in on) echoed in the prospectus' all-inclusive picture edit – featuring everything from paint rollers and headphones to the exterior of the building.

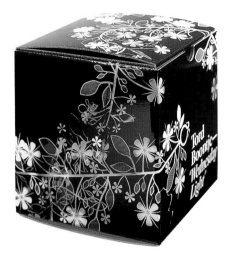

33. Packaging for Tord Boontje light
Design: Graphic Thought Facility, London 2002
Taking a prototype of a specially-commissioned box into the darkroom, GTF covered it with photographic paper, then wrapped Boontje's light (made of laser-cut steel) around it. After exposing the whole box they were left with a photogram of the steel shapes. GTF's Paul Neale realises they could have produced a similar image more easily by directly scanning the light itself, but argues it would have looked too ordinary.

to materials or technologies that were invented for a single, narrowly defined purpose, which they then manipulate in different ways; for example, building models out of cardboard or constructing photographic sets out of mirrors [p. 138]. 'We use process because process creates restrictions,' says Paul Neale. [32–3].

Linking old and new

Proof that the demands of the industry are changing is demonstrated by the fact that digital programmers have also been finding ways to link old and new forms of technology. John Maeda, for example, brings all the qualities of craftsmanship into his work. Some new forms of software are helping to encourage the integration of non-digital processes. It is now possible to have illustrative animation on websites, making it easier for graphic designers to incorporate personal image-making processes into a digital medium. Other programs are being developed that try to bridge the gap between letterpress and digital software – one that already exists can instruct traditional Monotype casting machines to produce metal type.

In the past, integrating old and new methods of production has led to some intriguing and innovative work, and today, with such a hugely diverse range available, the potential for new ideas is enormous. It has taken a surprisingly long time for designers to start exploring this potential as if, since the arrival of computers, they have been inhibited by the overwhelming capabilities of the machines on their desks. But the limitations imposed through restricting themselves to just one tool are finally driving many people to start mixing other techniques and processes into their work.

44

EDUCATION

Since the Apple Macintosh was adopted as the universal tool in graphic design, there has been a surprising lack of overlap between digital and non-digital processes. A major source of this inflexibility is education. Design courses have tended to separate old and new forms of technology, mainly because staff rarely have an equal understanding of both. On the one hand, there is the difficulty of training staff in new forms of technology; on the other, younger, digitally literate staff are in danger of spending all their time explaining the programs, instead of encouraging students how to think for themselves.

Young designers are now using digital media in the same way that previous generations felt comfortable with physical media; Quark, Photoshop and Illustrator have become their natural, everyday tools. To them a Macintosh is a means of artistic visualisation just like any other art-producing medium – but superficial knowledge of these programs can impede the quality of design work, just as superficial knowledge of any kind of tool can inhibit its effectiveness. Unfortunately, students often assume that when they learn how to use a computer program, they are also learning how to design.

New education strategies

Some design colleges are beginning to address these issues, partly because their staff are becoming better equipped in digital teaching through using the relevant technologies as part of their commercial practice. Teachers are trying to find ways to more effectively merge technology and ideas, encouraging students to think about the problem rather than the process and to integrate different techniques into their work [34 and p. 80]. At London's Royal College of Art, Alan Kitching is collaborating with some of his students to bring their digital expertise into his currently very non-digital letterpress courses, known as the Typographic Workshops. Kitching acknowledges that such amalgamations between the different disciplines are particularly interesting. 'Scanners and multimedia have given new life to letterpress as a source of unique forms and texture, and the web has brought a new young audience and world-wide contacts [...] I feel very fortunate to have worked during this era' [A Kitching 2001].

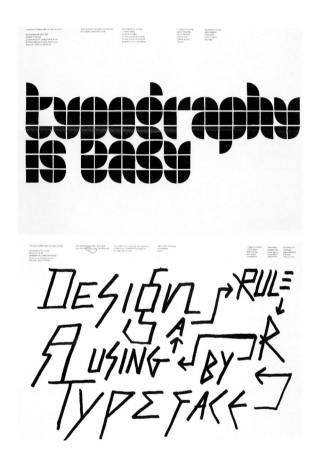

34. Teaching posters
Design: Henrik Kübel,
London 2001–2
Kübel uses these posters
to encourage graphic design
students at Buckinghamshire
College to think about letterforms,
allowing them to use drawing,
photocopiers and computers
to produce their own versions.
He doesn't mind what method
they use, as long as it fits the
brief. 'They realise they've got
thousands of typefaces in their
head without even going on a
computer,' says Kübel. (Top:
'Select two forms and make a
typeface'; bottom: 'Design a
typeface by using a ruler'.)

Central Saint Martins uses activities such as letterpress, drawing, printmaking and experimental photography as important learning tools to complement computer-based training, encouraging students to feel equally comfortable working on or off the computer.

The Codex Project [*www.graphics-csm.co.uk/dep/context/codex.html*]

In 2001, Susanna Edwards, Julia Lockheart and Mazier Raein – all lecturers at Central Saint Martins – set up The Codex Project. This stemmed from the general concern they felt, both as designers and teachers, for the lack of any real understanding in a predominantly digital age of the 'physicality' of the craft of design. The aim of Codex is to focus on problems facing graphic design education – in particular, the strategies employed by designers in response to the technological revolution. The idea is to encourage students to integrate different processes and to find unique solutions in their use of digital programs, instead of blindly accepting preordained procedures. The project's initial research generated such strong interest amongst participants that the debate was expanded into a discussion about the future of design and graphic design education.

Economic constraints

All this seems to offer some encouraging signs for graphic design education, but the first thing these kind of new initiatives draw attention to is financial problems. Too many design colleges simply lack the resources to be able to offer their students a wide degree of choice in processes and techniques. Most struggle to cope with just the expense of computers and the continual upgrading they demand. The upkeep of letterpress or screenprinting departments alongside this is often out of the question. Some establishments are turning to advertising companies for financial help, but this kind of deal can bring worrying pressures of its own that most colleges are reluctant to accept. Recently one or two advertising companies have actually been threatening to set up their own courses – what this entails for the future of design education we are yet to find out.

WEB DESIGN

When the internet revolution first took hold, web pages were rigidly set within a specific size. Since then, the medium has evolved away from conventional static expression via a variety of advanced technologies, enabling designers to explore the internet's potential in more adventurous ways. But the vast majority of web pages are still horrible: an illegible, confusing sprawl of matter 'designed' with the primary focus of attracting attention and showing off the latest gizmo or special effect. General navigation of the web lacks rules, and information-delivery strategies vary enormously between sites, so the chances of improving on the situation are slim. But for some designers, this challenge is part of the attraction. As demonstrated by recent examples of innovative use of the web, the use of animation also offers an interesting new dimension – one which might, theoretically, make up for the physical one lost through this form of technology.

Pierre di Sciullo

In 1996, Parisian Pierre di Sciullo was invited to produce a website showcasing his work. 'I find that most electronically produced pictures are very shallow, especially those done on 3-D programs,' he explained. 'My first reflex was to introduce objects which still have a body, their own identity. For the internet project I immediately thought of featuring my sketchbooks. Their intimacy seems completely contradictory to the public no man's land of the internet [...] it is the contradiction which interests me' [P di Sciullo 1996]. The spreads he created could be viewed by scrolling the screen horizontally or vertically but, just like a book, it was impossible to view more than one spread at once. Di Sciullo deliberately chose not to erase the imperfections or undulations of the scanned paper, but instead allowed them to take on new qualities on-screen, resulting in interesting, pixellated structures [37].

Objectifying interfaces

Tomoko Takahaki's Word Perhect (created in London in collaboration with programmer Jon Pollard) consists of an online version of a generic word-processing program that is specifically designed to undermine the dehumanising elements of this kind of software. Takahaki realised

35. www.frostdesign.co.uk
Design: Vince Frost,
London 2001
Frost used an unlikely combination of elements for his own website, making scanned-in, letterpress-printed characters the basis of the overall navigation system.

36. www.letterror.com
Design: Eric van Blokland
and Just van Rossum,
Amsterdam 2001
Van Blokland chose illustration as a refreshing change of pace from programming and building material for the web. 'I was struggling to find some sort of visual language for the commerce site,' he explains, 'I tried the official-looking clean approach but that didn't work [...] It needed to be really bombastic, but also personal.' He eventually thought this faux-nineteenth century solution was most fitting.

37. Introductory page of the 'Shapes in a Series' website
Design: Pierre di Sciullo, Paris 1996
This web page shows spreads from di Sciullo's sketchbook. The low resolution of the scans and the imperfections of the originals help to emphasise the personal nature of the work.

23."Shapes in a Series" is the introductory page of a Web site (http://www.vif.fr/proxima) showing spreads from di Sciullo's sketchbook. The low resolution of the scans and the imperfections of the originals help to emphasise the personal nature of the work.

44 EYE 23/96

48

**38. Word Perhect
Design: Tomoko Takahaki,
with technical director Jon
Pollard (commissioned by e-2
and the Chisenhale Gallery),
London 2001**
Takahaki's on-line word-processing
program reproduces the
conventional versions of
this software as a hand-drawn
interface, offering a set of
functioning but strangely
altered tools (web address:
http://e-2.org/word_perhect.html).

that as they become more advanced, with the ability to correct
syntax and spelling errors, these programs are beginning to impose
a standardised corporate language on people's writing, thus subtly
altering its meaning. Reclaiming the initiative back from the software,
Word Perhect presents an idiosyncratic hand-drawn interface that
leads to a set of functioning but strangely altered tools [38]. The project
raises questions about the concept of interface language, and the way
in which people respond to certain commands just because they exist
within the context of the screen.

New directions for web design?

The combination of rigid, analogue-based images and the fluidity
of the web page works surprisingly well – which again goes back to
the idea of mixing technologies. Despite its apparent sense of freedom,
web design is one of the most limited forms of digital technology,
depending heavily on inflexible programs and restricted by having to
work for different browsers. Consequently, sites have started to look
monotonous, so the introduction of an external device – like a hand-
drawn animation – becomes the most effective way of introducing
some variety. The fact that, as designers become more experimental
in their ideas, programs develop in ways that encourage them to mix
in other processes, suggests that the future of web design may well
be heading in a more organic, handmade direction.

[AN INTRODUCTION TO THE STUDY OF COLOUR VISION.]
BY SIR JOHN HERBERT PARSONS.

The colour spectrum.

44 43 42 extreme violet. 40 extreme violet. 39

432103

196
blue

BLUE
VIOLET.

45

blue / purple

·42 blue violet.

purple / dark.

39
violet.

nm - one ten millionth

ten millionth part of a
11 metre.

A typographic representation of the colour
spectrum BY KIRSTY CARTER
laying.

Kirsty Carter

'A typographic representation of the colour spectrum' letterpress print (London 2001)
This print was created as part of one of Alan Kitching's Typographic Workshops at the Royal College of Art. It is a visual representation of the colour spectrum using letterpress, intended as an interpretation of the word 'cornucopia'. Carter used colour as a means of creating a sense of control, and, 'to understand better an element of design that I use every day.'

The spacing between each letterform relates to the wavelength of each colour (known as 'Ms' in letterpress and as 'NMs' in the prismatic spectrum). The result is a curious combination of the mathematical and the accidental.

Carter describes how the project enabled her to learn about the nature of colours and the ways they interact, as well as about the measurement systems of letterpress and the implications of letter spacing. 'Through it I discovered a way of presenting the viewer with finite information while still allowing for the possibility of chance and subjectivity,' she explains.

52

Début Art portfolio (London 2000–2)

The directness of application, the immediacy of the result and its adaptability to change and decision-making are, for Alan Kitching, the principle attractions of letterpress. Kitching sees letterpress as a means of self-expression for both artists and designers – one that allows them to escape from what he considers to be the unsatisfying uniformity and blandness of digital design and print. He never believed that computers would completely take over from letterpress, but realises that they have pushed his own work out of the realm of graphic design and into that of illustration. Kitching sees that the fact that high-quality reproductions can now be easily obtained with so little effort has removed one of the essential challenges of graphic design.

Kitching is currently represented by Début Art, a London-based art and illustration agency. Since the mid-90s, his work has started to engage more with the exploration of the artistic potential of letterpress. With most commissions, his focus is not on the layouts or the quality of reproduction. Instead, Kitching uses each job as an opportunity to produce a one-off piece of work that enables him to experiment freely – typically he works with overprinted colours and incorporates unusual shapes and forms from old type trays into his designs.

WEDGE, DOUGH, CASH, GREEN, WONGA

By Philip Beresford

Skills for the new librarian

REAL BUSINESS

IF YOUR BUSINESS IS YOUR PASSION...

OCTOBER 2000 £3

'ENOUGH IS ENOUGH'

WHAT YOU ARE TELLING US ABOUT RED TAPE

54

NEW BOOKS '96:'97 FICTION FICTION 2 12 NON-FICTION GUARDIAN BOOKS 38 PAPERBACKS 40 41 BACKLIST INDEX 44 SALES 42 43

Catalogue for Fourth Estate (London 1996)

Vince Frost uses letterpress as one way of bringing a tactile quality into his work. 'It has a look of personality and an aura about it that computers cannot simulate,' he says. Frost is particularly interested in the way letterpress forms a bridge between commercial work and craft, but emphasises the importance of knowing when to use it.

This 46-page catalogue, printed in one colour throughout as an edition of 10,000, is the largest project in recent years to use letterpress. The typographic illustrations solve the problem of the publisher having to confirm cover designs too far in advance. (Because decisions about what covers will look like often have to be made before the book has even been written, design solutions are invariably rushed or inappropriate.)

Artist's catalogue
(Biel, Switzerland 1997)

This catalogue was designed for artist
Markus Furrer's collection of plaster of
Paris sculptures, the forms of which are
derived from polystyrene packaging.
Weidmann used the basic shape of
the packaging to create a template that
he used to overprint each page of the
catalogue in a white, silk-screened ink,
thus referencing both the shapes and
colour of the artist's work. The slightly
raised areas of white ink give the catalogue
a three-dimensional look and tactile
feel, and the overlapping shapes create
forms that subtract or add to the
background image, mirroring
the qualities of the sculptures.

The images are low-resolution black
and white photographs that Weidmann
reproduced using his own laser-copier.
By using a tinted paper, Weidmann was
able to combine the white ink with the
black laser prints to achieve a wide
variety of tones.

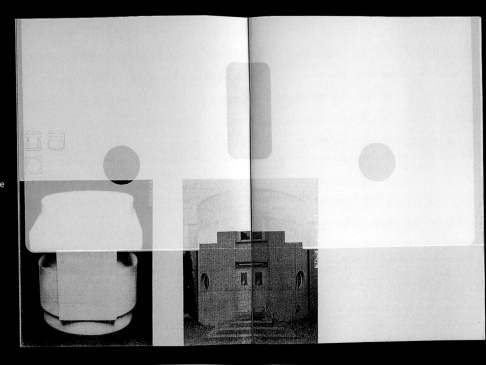

BÜROGEBÄUDE, SCHWARZWALDALLEE, BASEL TECHNICS SC-HD

58

PAINT REMOVING EXERCISE
Royal College of Art Entrance Gallery 17 January 2000
Polythene Dust Sheet 6m²

INSTRUCTIONS
Equipment required: Sponge, flat scraper, wire brush, sand paper.
Protect all immovable furnishings, electric's and flooring with supplied polythene dust sheet.
Remove all emulsion

Soak painted surface with water. Remove all dampened paint with flat scraper. Scrub patches of excess paint, using wire brush. Remove fragments of paint, using water and scraper. Remove uneven surfaces with coarse sandpaper.

Use an alternative to Vinyl Emulsion paint such as specialist environmental paints (available mail-order) from Auro 01799 5848888 and Livos 01952 883288

HARMFUL

BRILLIANT WHITE VINYL EMULSION

1. Contains Volatile Organic Compounds (VOCs). These compounds are substances which evaporate from petroleum solvent paints. Asthma, Allergies and Sick Building Syndrome (with flu-like symptoms) are caused or worsened by the release of VOCs.[1]

2. VOCs are considered to be the reason for decorators' risk of lung cancer being increased by 40%.[2]

3. Vinyl emulsions continue to 'offgas' VOCs for a considerable time after application.[3]

4. VOCs emissions contribute to smog and low level ozone formation which, amongst other things, can injure plants and contribute to global warming.[4]

5. Production and manufacture of vinyl emulsion paint in the UK creates 55,000 tonnes of VOCs pollution per year, nearly as much as road vehicles (65,000 tonnes per annum).[5]

6. The production of 1 tone of Vinyl Emulsion can result in up to 30 tonnes of waste.[6]

7. The Vinyl referred to is Polyvinyl Acetate. A Swedish study of Polyvinyl Acetate production found that 40% of workers had some form of occupational skin disease.[7]

8. The biocides and other ingredients in Vinyl Emulsion paints can be serious water pollutants if it enters the drains through brush washing or disposal.[8]

9. The pigment Titanium Dioxide (TiO²) is added to provide opacity. It accounts for the majority of the energy consumed in production and it causes water pollution, respiratory problems, skin irritation.[9]

10. The main impacts of paint manufacture are the high energy processes required and the use of (non-renewable) crude oil as the raw material. The Petroleum Industry generally is a major source of greenhouse gases and acid deposition, and is responsible for over half of all emissions of toxics to the environment.[10]

Brilliant White Vinyl Emulsion was produced in the UK for **Johnstones Jonmat/Leyland Paints.**
Manufactured by **Kalon Decorative Products, Huddersfield Road, Batley, West Yorkshire W1F7.**

Kalon Group is a company of
Total, Tour Total, 24 cours, Michelet, La Defense, 10, F-92800 Puteaux, France.

Total is involved in twenty oppressive regimes, including joint venture with the repressive military regime to build a pipeline across Burma to Thailand. Apparently, thousands of indigenous people have been relocated and forced by the military to clear forest and build roads and railways for pipelines. There are also allegations of torture, rape and murder at the hands of the regime. Aung San Suu Kyi, leader of the democratically elected government prevented by the military from taking power, has described Total as 'the strongest supporter of the Burmese military.'[11] **Total's taxes paid to Burma's military regime amount to approximately US $200 million.**[12] **A boycott of Total was called by the Methodist Church in June 1998 over Total's investment in Burma and France's nuclear testing.**[13] **Total's US $1 Billion gas pipeline, which runs from an offshore gas field overland to Thailand was reported that slave and child labour was used during building of the pipeline.**[14] **Total had 4 oil spills in 1996, taken into account when oil is released in production the total amount of oil released by Total was 86.5 tonnes. More recently the Empress Tanker leaked 72,000 tonnes of Total's diesel oil on the West coast of France. The diesel oil spread over 300 miles of coast line, killing 300,000 varieties of sealife and birds. The incident has been described as an economical disaster for the local communities.**[15]

References 1. **Building for a Future**, Winter 1998. 2. **Simply Build Green**, John Talbot (Findhorn Press), 1995. 3. **Eco-Renovation**, Edward Harland, Green Books 1998. 4. **Paint the Room Green**, Environmental Building News, February 1996. 5. **Simply Build Green**, John Talbot (Findhorn Press), 1995). 6. **Ethical Consumer** April/May 1999. 7. Simply Build Green, John Talbot (Findhorn Press, 1995). 8. **Ethical Consumer** April/May 1999. 9. **Greener Building** - Products and Services Directory, AECB 1998. 10. The Global Environment, Two Decades of Challenge, MK Tolba. 11. **Down to Earth**, International Campaign for Ecological Justice in Indonesia May 1997. 12. **Corporate Watch**, from Reuters 13 November 1996. 14. **Financial Times** 28 November 1995. 15. **Corporate Watch**, John Pilger, December 1996.

The Royal College of Art gratefully acknowledges the substantial help and support it receives from sponsors Leyland Paints.

Concept and Communication by **Darren Hughes** 00.01.17

Paint Removing Exercise [left]
(London, 2000)

Hughes initiated these projects during his degree course at the Royal College of Art as a protest against globalisation and as a means of challenging attitudes towards moral responsibility. When asked to exhibit his work on the walls of the RCA gallery, he decided to work directly with their surface rather than simply hanging new work, realising that the walls themselves had social, environmental and political significance.

White emulsion paint interested Hughes as something that people take for granted but which surrounds them, so he decided to create a piece of work that would damage a pristine white surface and make the audience look twice. The piece invited people to take part in removing layers of emulsion paint that had been applied over the years.

Paint application [opposite]
(London, 2001)

Again Hughes was invited to exhibit on the walls of the RCA gallery. He decided to revise the first exhibit 'Paint Removing Exercise', this time focusing on an environmental theme.

Discovering that a great deal of paint was wasted when the walls had been painted, Hughes decided to collect all the tins of waste paint from the college skip and use it to repaint any unpainted walls in the exhibition. He made a large stencil of instructions that he sprayed directly onto the walls, inviting the audience to repaint them using the supplied paint rollers and brushes. The stencil itself was eventually covered up when painted over – always to exist within the walls.

Paint Application
Rescued Waste from The Show: Par...

Material: Brilliant Matt White Emulsion
Volume: 1 Litre

Source: Royal College of Art
Coverage: 12 Square Metres

Application:

1. Fill one-third of tray with paint 2. Dip roller into paint & run on tray 3. Apply to wall pushing back & forth 4. Repeat...

Coverage:

Height:

Signage system for the Royal Academy of Dramatic Arts (London, 2002)

The idea of this signage system is to guide people in a humorous way, using quotes from various plays that relate to places in the RADA building. The texts are laid out using the same typographical conventions as the script of a play. Specific areas of the building appear in capitals, as the characters in a play would; the directions are given in the style of stage directions (written in italics in square brackets); and other additional information is written in roman text, as the spoken words of a play would be. 'We aren't using arrows but written text to guide people around in the building, creating a kind of scene,' say the designers, who also chose a selection of quotes to scatter throughout the building.

In keeping with the idea of a pastiche, the graphics had to look analogue-based rather than computerised. The text was therefore first set in metal type and letterpress-printed, then enlarged to the required sizes using repro-cameras, and finally, screenprinted directly on to the walls of the building. 'We manually set the texts in letterpress to maintain the authenticity of traditionally printed books,' explain the designers. 'In original as well as enlarged forms, letterpressed type has a special character and charm, as opposed to the anonymous appearance of mass-produced, digitally printed type.'

Each sign is printed on an off-white background that contrasts with the bright white of the building's walls, giving the impression that they predate the reconstruction project as well as resembling, as far as possible, a printed page.

11. 12. 13.
For the signs we produced, we manually set the texts in letterpress to maintain the authenticity of traditionally printed books. In original as well as enlarged forms, letterpressed type has a special character and charm, as opposed to the anonymous appearance of mass produced, digitally printed type.

"... I will go with thee and be thy guide..."
EVERYMAN

"Though this be madness yet there is method in it."
HAMLET, William Shakespeare

For the LIFT turn left.

"Walk! Not bloody likely."
PYGMALION, George Bernard Shaw

"But soft! Methinks I scent the morning air."
HAMLET, William Shakespeare

[For the EXIT walk across the Foyer, turn right.]

[For the TOILETS walk straight ahead.]

"But good God, people don't do such things!"
HEDDA GABLER, Henrik Ibsen

[SCENIC ART DEPARTMENT, LOWER GROUND FLOOR]
"All my lousy life I've crawled about in the mud!
And you talk to me about scenery!"
WAITING FOR GODOT, Samuel Beckett

Handwritten annotations: DONE! · Bembo 24 Roman · LIFT · Bembo 12pts · Shakespeare · william · baskerville! · done! · Frankenk! · baskerville · BEMBO 30 · (soft) · (morning) · (morning) · (thinks) · TOILETS · space · space! · space!

Posters for AIGA (New York 1996, 1997 and 1999)

Stefan Sagmeister started introducing hand-drawn script and organic forms into his work when most other graphic designers were still using predominantly digitally-based imagery. For his series of AIGA (American Institute of Graphic Arts) posters, Sagmeister needed to come up with something surprising, partly because they were self-promotional, but particularly because they were aimed at an audience made up of other graphic designers. His solution involved creating images that were entirely organic – in direct contrast to the material being produced by his contemporaries.

For his 1996 poster, Sagmeister depicted the 'wagging' tongues of cows (human ones were not long enough); then for the 1997 graphic, he digitally created his own 'chicken-foot' typeface [detail below]. His most notorious poster – for 1999 – involved having text scratched into his own body. The idea was to reflect the struggles involved in being in the design profession, which Sagmeister describes as 'the anxious periods, the fighting and the pain.' Peter Hall, author of Sagmeister's manifesto-style book *Made You Look*, describes how 'twelve years of computer-driven design had initiated a backlash in favour of the tactile and hand-hewn – anything that showed physical evidence of a creator and evoked an equally physical response.'

Stefan Sagmeister

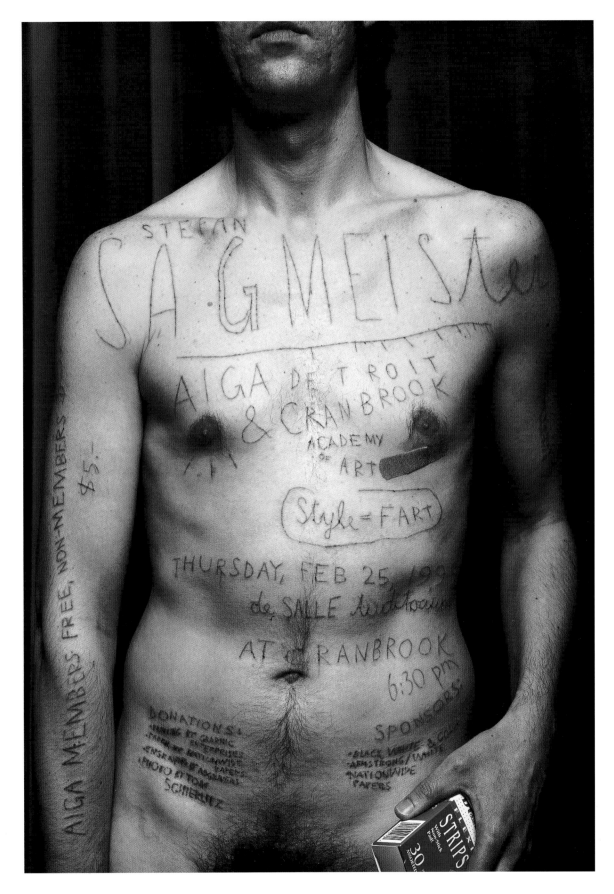

Preliminary work for typographic candles (London 2001)

Graphic designer and typography tutor Phil Baines was trained before computers were in common use, and is aware that his working practice is coloured by this experience. He now works predominantly in front of the screen like most other designers, and is convinced that, typographically, computers are by far the best tool since they allow him a degree of unprecedented flexibility.

However, Baines does have two particular criticisms of computers. First, he has noticed a tendency amongst designers to use them to 'clean' everything and to make everything very 'smooth', which he thinks can be a problem as not every job suits this treatment. Second, Baines says computers are no good for sketching as they are too slow.

For all his own type designs, Baines first makes rough drawings onto paper as an *aide memoire* before working directly in Font Studio. The examples illustrate the original sketches for the typographic prints he designs each year to wrap vertically around church candles to celebrate Easter.

Oreon
Typofa
Squire
QSalm

LettError typefaces (Amsterdam 2001)
In 1990, at what he describes as 'the height of the grab and scan typeface revolution,' Eric van Blokland of the LettError type foundry sketched a broad-nibbed typeface in pencil that he called 'Oreon'. The typeface was never published as van Blokland found he could not match the same roughness of outlines, level of detail and text colour in trying to create an italic and capital character set, so he decided instead to make a 'neater' version. The first adaptation of Oreon was 'Kosmik', a hand-drawn font based on a complicated process that made the type more lively by switching around alternatives in the manner of 'Beowolf' – one of their earlier typefaces [p. 85]. Here the characters appeared slightly different each time they were printed. 'Federal', 'Zapata' and 'Typoface' followed on from this, using the same design principle.

A few years later, van Blokland decided it was time to draw a new version of Oreon (partly due to having noticed that his mother was using the fonts for her design work!). First he produced 'Squire', so-called because he wanted to show 'the funky Q'. Within a week, Squire was transformed from a wobbly, hand-lettered sketch to 'Salmiak' [right]: 'still wobbly, but regular enough to be useful, and quirky enough to differentiate it from the tons of other Bodoniods,' says van Blokland [see www.letterror.com].

Eric van Blokland and Just van Rossum

ABCDEFGHIJK
LMNOPQRSTU
VWXYZabcdefg
hijklmnopqrstuv
wxyz1234567890
ABCDEFGHIJK
LMNOPQRSTU
VWXYZabcdefgh
ijklmnopqrstuvw
xyz1234567890@

68

Layouts for *World of Art*, published by Thames & Hudson (London 2002)

Derek Birdsall (who trained in the 1950s) has never learned how to operate a computer. Although he hasn't altogether abandoned the idea, he is generally dismissive of the value of digital technology in graphic design, depending instead on other people to typeset text for him on a Macintosh. 'I can beat the hell out of computers!' says Birdsall, pointing out what he regards as their two fundamental flaws: first, that objects cannot be physically picked up and moved around, and second, that there is a restricted sense of scale.

Birdsall uses the traditional cut-and-paste process for laying out pages. First he specifies the measure so his daughter, Elsa, can typeset and print out the columns of text. Birdsall cuts these into strips, then tapes them into position on the layout sheets. He thinks colour is unnecessary at this stage, except to mark the difference between colour and black and white sections, for which he uses yellow or white layout paper respectively. The pictures are scaled mathematically rather than visually. 'You can easily imagine how they will look,' says Birdsall.

Elsa then recreates the layouts digitally, positioning the text and enlarging or reducing each picture to fit the allocated space. Sometimes Birdsall will make further changes at this stage.

word for womb, hysteron, makes plain its gendered origin. In the subsequent period leading to World War I, however, nationalist writers like Henri Massis and Ernest Psichari attributed a declining French birthrate to the neurasthenic dandyism of the previous generation and raised worries about a lack of military preparedness. These writers and many Cubist artists turned to Bergson's vitalist doctrine of élan vital and looked for evidence of its resurgence in a youthful generation who had rejected the 'lethargy' of the older Symbolists.

In the art of Cubism's male practitioners, the élan vital is identified with iconic images of the female nude, symbolic of the biological fecundity permeating the natural world. The most famous Cubist example of such imagery is Le Fauconnier's *Abundance*, exhibited in the 1911 Salon des Indépendants. The preceding year Arcos, Gleizes, Mercereau and others had followed the painting's development during weekly meetings in Le Fauconnier's studio, and the theme of fecundity symbolized by the monumental nude had a counterpart in the poetry written by Mercereau and Arcos. In Le Fauconnier's image, the nude female not only gathers nature's fruit, she is accompanied by a child, the organic product of her own fecundity (the abdomen of Le Fauconnier's allegorical female is placed at the centre of the picture to highlight this theme). Rooted in the land, both child and mother are painted in earth colours and the angular treatment of their anatomy echoes that of the panoramic landscape. The themes of regeneration and fruitfulness in the painting echo Mercereau's Bergsonian ode to female fecundity in his *Paroles devant la vie* (1911), as both men embraced Bergson's association of organic regeneration and evolution with duration.

When the Cubists developed a male counterpart to images like *Abundance* they invariably represented a cultural activity, usually competitive sports. Indeed, in 1912 Bergson himself described the revived interest in sport among the French as evidence of the *volonté créatrice* (creative will) animating the younger generation. Bergson's correlation between male *volonté*, sport, and the creative capacities of French youth was taken up in Agathon's *Les jeunes gens d'aujourd'hui* (*The Young People of Today*) (1913), a highly popular book that employed Bergson's terminology in a promotion of French nationalism. Citing Bergson, Agathon associated the youth's 'life energy' with their 'anti-intellectual' attitude and love of sport. 'Sport', we are told, has created a 'patriotic optimism among young men'; moreover 'collective sports like football' produce a 'spirit of solidarity' reflective of 'military virtues'. As historian John Bowditch has shown, Agathon's description of this Bergsonian esprit de corps

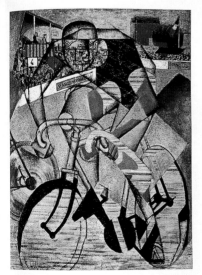

122. Jean Metzinger,
The Cyclist, 1913.
Metzinger celebrated the salutary effects of exercise on the male population in his *Cyclist*, which focused on a sport that historian Eugen Weber has described as a French creation, and one affordable to the French working class by 1900. Metzinger understood its patriotic origins by flanking the cyclist with a poster advertising the Paris-Rouen Race, a reference to the first long-distance race inaugurated by the French in 1869. The transparent planes of the cyclist's face suggest the simultaneity of his action with that of the crowd, while the flag of the Republic flies on the upper right.

144

was lighted in with ashing and toilet facilities

a specified position great pleasure toilet facilities

to have joy given state

toward a such occupy a relation to

of this kind sweet

a pleasing disposition smelling

perceive the scene of

company guest

,

unfortunately regrettable

Lavender plant with purple flowers

wasn't express negations

and connect words

began started an activity

to a direction toward

becom limit

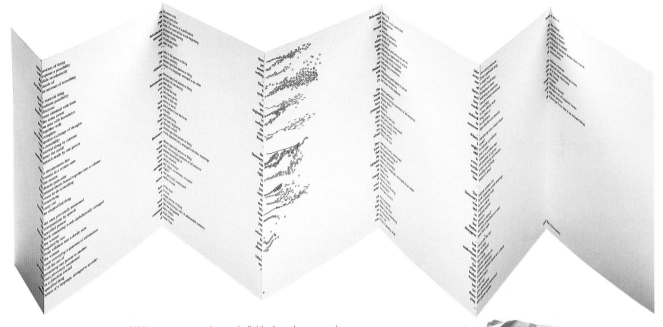

'Dictionary Story' (London 2001)

SamWinston's work is about mixing language with form. He attributes much of his inspiration to his dyslexia, which he says makes him think about words in a different way. His reading relies on both visual and verbal patterns in text, so he is fascinated by the relationship between descriptive words in English and expressive forms in art.

'My work is about the balance between my internal understanding of words and how they are understood in the conventional sense,' Winston explains. 'With the "Dictionary Story" I was exploring the notion of reading environments – the spaces that are created when people become "lost" inside a book.' He asked himself what would happen if words could take on their own meaning without the help of the reader. 'How would "anger" respond if he met "apathy"; what would happen if "lawless" bumped into "lawn"?' he wondered. Winston's aim was to make the text take on its own personality and character before it has been read.

Winston first constructed his story by working physically with books and pages of typeset text, either cutting out whole sections or individual words, or screwing pages into balls, then photocopying whatever he was left with so he could watch the effect of the words randomly butting up against each other. He used these as a reference for each of the four final pieces. Winston's words, which have been painstakingly typeset in Quark in individual text boxes, are intended to move according to their meaning, literally 'flying towards the spine'.

all day i dream about Sexymachinery

(Part 1)

Pixelpeople Have Left The Building / Lina Dzuverovic /
Russell

The following pages feature a collaboration between sexymachinery and the
Pandæmonium Festival – the Biennial of Moving Images, which took place in the early
part of 2001. Four artists and groups were commissioned to make new works for the
Emerging Technologies section of the festival, and in parallel, for sexymachinery.

The exhibition profiled the work of artists who are each positioned at very different ends
of the spectrum of digital media production and who each create...
image work. Making a moment brought on by the convergence...
digital video, programming, animation, design and sound, the cul...
of communities, approaches and techniques.

The corner / Martin Gaeger

/ Vanessa Billy

An A4 sheet of paper
can be folded four times
the fifth it wrinkles.

Call for entries / Sexymachinery

to submit any of the following:

RIOSITIES
DIARIES
DRAWINGS
DREAMS
ESSAYS
FACTS
FICTIONS
IMAGES
SATIRES
SCHEMAS
STORIES
WORDS

Sexymachinery (London 2000–2)

In July 2000, the designers from åbäke collaborated with Shuman Basar and Dominik Kremersko – then at the Architectural Association – to produce the magazine *Sexymachinery*. The format is both derived from and reinforces the idea behind the publication, which the editors claim, 'will locate within architecture the mechanisms of pleasure, desire, public fantasy and ardent enjoyment.'

The first edition was produced as an edition of 1,000 and had to be collated and bound by the designers because of the low budget. It consists of a set of pages in a range of five sizes, bound by a removable clip and individually wrapped in various styles of wallpaper which serve as the cover [right]. The reader is instructed that if they wish they can take out the pages and replace them in a suggested order, or another sequence of their choosing.

The covers of the second edition are made from sewn household cloths, available in the standard blue, green, pink and yellow [left]. 2,000 copies were produced, and again åbäke had to collate the contents and make the covers themselves. The pages are unbound and folded, each with a slit cut into the centre that enables them to be made into three-dimensional booklets, following instructions included in the set.

**Graphics for 'Designer's Block'
(London 2000)**

Susanna Edwards divides much of her time between the letterpress department and the photographic studio at Central Saint Martins, both of which she gains access to through her teaching. Edwards' work is experimental, unplanned and tactile, and often made up of a complex series of layers that may combine several processes. 'My work originates from traditional, hands-on ways of working such as letterpress and printmaking, but crosses over into areas such as photography, web design, audio-visual and fine art,' she explains.

In 2000 Edwards was commissioned to produce the graphics for the exhibition 'Designer's Block' – a showcase of work by contemporary product designers focusing particularly on low-budget, experimental design solutions. The project included the concept, art direction and design production of all exhibition graphics, printed material and the show's website. In line with the 'Designer's Block'

philosophy, Edwards used letterpress as the basis for the show's identity, producing a series of simple graphic devices that could work either individually or together and that could translate across a wide range of media that included catalogues, invitations, flyers, exhibition graphics, stationery, signage, the website and even a set of rubber stamps.

The logo itself was created using a complex procedure that combined several processes. First, Edwards filmed a letterpress print she had made using a digital camera, from which she selected a still to import and work on in Photoshop. She made a new letterpress plate from the digital file, then used this to make a second print. Next, Edwards produced a series of photograms in the colour darkroom, then scanned and manipulated these digitally for the website.

The website [right] was made via a collaboration between Edwards and Fred Wheener from the then-prolific internet company, Deepend.

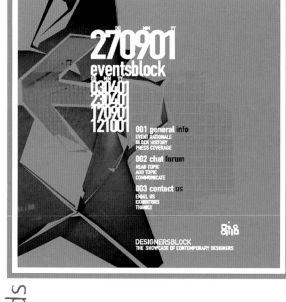

Susanna Edwards

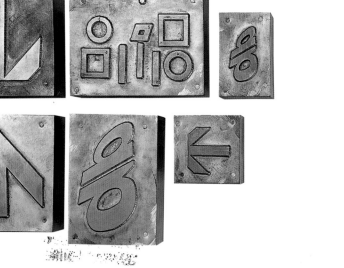

76

**CD designs for Sony Music
(New York 2001)**

Stephen Byram is a graphic designer,
but his work is actually more like fine art.
Working predominantly as a record and CD
designer, he has the opportunity to express
himself relatively freely. Typically, Byram
avoids the standard perspex CD jewel-
case, preferring cheap, uncoated board
or corrugated card packaging, and the low
resolution and imperfections in his messy
and sprawling illustrations help emphasise
the personal nature of his work.

Byram works closely with a small
team of collaborators who help spark ideas:
illustrator Jonathon Rosen, photographer
Robert Lewis and fine artist Betsy
Byrne. Often he does everything himself,
immersing himself in the music before
coming up with an idea. 'I make lots of
drawings then scan them in, chop them up,
and put them back together in Illustrator,'
Byram explains. For 'Trick 3' [bottom] he
printed out the image then attacked it with
a marker (called a 'designart pen' in the
US) that dissolves ink. The marker works
on the ink that comes out of a laser-copier,
softening and blurring it.

Byram is aware that much of the focus
of the current commercial recording industry
is on the images of pop artists, rather than
music. He has little interest in doing projects
for companies with this kind of attitude,
who he thinks don't deserve imaginative
packaging. Byram's work deliberately
rejects convention, for example, avoiding
the predictable use of type on the covers.
He has trouble convincing clients who have
grown increasingly influenced by the
commercial style that his own approach will
work. 'By the late 1980s I had a flat full of stuff
they [the Columbia label] killed. I had one
cover killed because someone said it didn't
look like any other record cover, and if they
put it in a store, people wouldn't know what
it was!' [quoted in *Eye* no. 42, p.47].

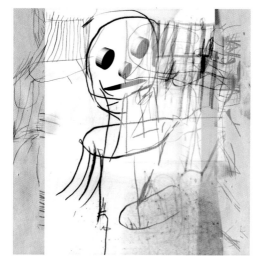

Paraphrase: please Advise

Tim Berne Drew Gress Tom Rainey

Magnetic man light sculpture, Cayenne (Belfast 2001)

This 40-foot long, digitally operated ceiling sculpture is the dominant piece in the restaurant interior Peter Anderson (at Interfield) was asked to design by celebrity chefs, Paul and Jeanne Rankin. The exposed surface of the lightbox is covered in a layer of semi-opaque film, into which transparent words have been laser-cut.

Anderson wrote the words himself, using his knowledge of early Irish folklore and its 'bewitching connection' with food. He integrated traditional-style text with words taken from a piece of Javascript, which, when programmed into a computer, would cause everything on its desktop to gently rotate or stir. The result is a contemporary poem that acts as a 'spell' designed to entice people into the restaurant while simultaneously, through the form of the sculpture, it expresses the seductive power of today's technology. Anderson's intention was to 'take language to another level by using it to create a physical event', and to do so in a way that is inviting rather than off-putting.

The form itself relates to the restaurant's architecture, and is able to anticipate the behaviour of people in the restaurant: 'It's a fusion of their reaction and the space,' explains Anderson. Twelve different, sound-sensitive movements are programmed into the sculpture, which cause waves of warm, orange and red light to sweep across it. The light movement responds to specific types of noise, which are transmitted through microphones in the restaurant. When the atmosphere is calm, the colours gently undulate; when it is active, they ripple as though the words might be chatting to each other – and a sudden clap or broken glass will prompt a violent shiver.

Dogme project, Stuart Bailey (Amsterdam 2001)

Bailey set this short-term project for his final year students at the Rietveld Academy, basing it around the Dogme 95 Manifesto. 'When the first two Dogme films – *Festen* and *The Idiots* – were released in 1998, I loved the films but was disappointed by the publicity,' explains Bailey. 'I'm interested in what would happen if the posters shared the same spirit as the films.'

The idea was for the students to design two film posters that captured the style of the Dogme films, which were originally intended to be exclusively focused on the film-making process.

The students spent the first part of the project watching a selection of Dogme films in an attempt to define the meaning of the word 'spirit'. The ideas they came up with had little to do with the marketing ideas that earlier publicity seemed to focus on. Some involved audience participation, some exposed the method of production, some represented the films metaphorically and some commented on the media hype. These examples are by Daphne Correll [left] and Chantal Hendriksen [right].

WK 46 / Festen / D#1

WK 46 / THE IDIOTS / D#2

Commercial work

84

MISTAKES

As the digitisation of the design process has resulted in the ironing out of many of the inevitable imperfections of preceding craft-based processes, so designers are beginning to build flaws into their work in an attempt to counteract the 'slick look'. Often they adopt methods that force unpredictable things to happen, exaggerating the 'errors' to create a greater sense of 'authenticity'. In some instances this is a strategy with which to generate ideas; in others, the mistakes are introduced purely to provide a particular kind of aesthetic [1–2].

Apple Z

The fundamental difference between digital and analogue methods of designing is the command 'Apple Z' – digital programs can 'hold' a number of options and outcomes in their memory, thus allowing designers to endlessly 'undo'. The consequence of this tends to be that more mistakes make their appearance only after a job has been completed, having remained hidden in the complexities of the programs. Although the search for ever-greater forms of graphic 'perfection' continues, current technological conditions have probably enhanced rather than lessened the value of mistake-making in design. People have grown so accustomed to non-varying type and precisely rendered facsimiles that now, more than ever, they are responding to design that incorporates slight inaccuracies. In his analysis of the hundreds of classic remastered fonts that are now available in digital form, London designer Martin Dawson concluded that a perfect facsimile of the original never seems to work: 'The small variations resulting from the printing process are what makes the original so appealing,' he says [M Dawson 2001].

Deliberate 'mistakes'

Some type designers have been challenging the notion of technological perfection by building in 'handmade' inaccuracies to digital programs. Eric van Blokland and Just van Rossum are of the opinion that absolute regularity in type is unnecessary for reading, and that a certain roughness or unevenness is actually pleasing to

1. *Baseline* magazine cover
Design: Susanna Edwards, London 1996
The abstract letterforms are derived from a process Edwards 'discovered' accidentally (although it is a well-known trick in the printing trade): printing from wooden type on the reverse side of a wet print, then feeding a separate sheet of paper through the press underneath the wet print. The final image reminded Edwards of the way type can be deconstructed in Fontographer – transforming a traditional medium into something almost futuristic. (Her final design was inspired by London's Battersea Power Station.)

2. 'Chance' leaflet
Design: Stuart Bailey, Amsterdam 1998
Bailey visited and spoke to various graphic designers, intending to compile their thoughts about the notion of chance into a magazine article. Concluding that the chance events that had happened during the visits were more interesting than the intended article, he wrote and produced this leaflet to mail back to the participants. The design is based on a lucky moment when Bailey spotted a Monopoly Chance card lying on Charing Cross Road (in London) on his way to meet one of the participants.

abcdefghijklm

3. Beowolf
Design: Eric van Blokland
and Just van Rossum,
Amsterdam 1989
Here, all points on the contour of
a (fairly) normal typeface are given
a space in which they can freely
move, so instead of each letter
having a single fixed form,
they move or 'wobble' – so that
every letter this typeface prints
is unique. If characters are
repeated in a text they will have
different shapes.

abcdefghijklm

4. Marcel Duchamp Dirty
Design: Fabrizio Gilardino,
Montréal 1999–2000
Gilardino wanted to create a 'noisy
and polluted' version of Letter
Gothic that would still be legible
and easy to use. The characters
were printed then the prints were
rubbed with sandpaper, cut and
re-pasted together with
adhesive tape. The resulting
characters have been scanned
and re-worked in Photoshop
before being imported into
Fontographer. 'It reflects my
interest in combining handmade
and digital-made elements within
the same project,' says Gilardino.

à manger, Passe-moi le pain, Plus
quelle heure est-il? dit la fille,

s'essuient la bouche et la fille se penct
pour lui dire quelque chose à l'oreille

la fille sort de la chambre et revient
à lèvres, Elle se met sur la mère et la
bouche et les joues, Lui fait enfiler
jours au lit, Elles rient, La fille met

5. Catalogue for
'Kiss and Shoot'
Design: Mevis & van
Deursen, Amsterdam 2001
The 'Kiss and Shoot' exhibition
featured film and video, so the
designers decided to represent
the idea of movement by
overprinting the texts in a
slightly different position each
time, deliberately making them
appear out of register to a
varying extent on every page.

the eye; 'The sameness of type seems an arbitrary thing that we can do away with in certain cases,' they explain. A character that has a rough edge suggests that some imperfect production technique has been used; if such a character is vectorised and put into a font, each of its elements is copied exactly so every imperfection and bit of dirt is replicated. In an early experiment, van Blokland and van Rossum reprogrammed Postscript software so that the outline of each character of the set would change randomly each time it was printed. Their font, 'Beowolf', gives the deliberate impression of being flawed and as such, implies that some form of technology other than a computer has been used to generate it [3]. Montréal-based Fabrizio Gilardino used a more physical technique for his mutated version of Letter Gothic [4].

For their book *Kiss and Shoot*, Mevis & van Deursen introduced a deliberate 'mistake', this time using standard computer-generated fonts. They manipulated blocks of text, duplicating then repositioning them on top of each other to varying degrees on each page so they would appear out of register [5]. Goodwill interpreted this idea even more literally with his controversial design for an artists' catalogue. He made the book look spoiled and polluted by adding scanned-in pieces of dust and dirt and deliberately damaging the bound pages. Goodwill's intent was to represent the multicultural nature of the artists involved in the show, all of whom had mixed racial origins [6].

Changes in mistakes

London designer and writer Anna Gerber recently wrote, 'the beauty of accidents seems to have been airbrushed from day-to-day discussions and working methods. We need to remember that the creative process is not only victim to accidents but also in constant need of them' [A Gerber 2001]. There is some truth in Gerber's statement, but in some ways it is misleading, as mistakes can never be eradicated totally from design, as from any other process. The situation is more that the way mistakes are manifested has changed. Graphic designers are increasingly manipulating digital processes to introduce or generate their own mistakes, although this kind of

6. *In the Mean Time* jacket (detail) [opposite] and poster [left]
Design: goodwill, Amsterdam 2001

This artist's project was based on the notion that people are made 'impure' through the accents and experiences they pick up by living in different places. goodwill decided to represent these ideas by adding his own invented typographical accents to the texts, which he highlighted in the book by circling them with a red pen. He also included scanned smudges, pieces of dust, dirt and the odd hair. In addition, goodwill instructed the printer to leave in any 'spaniards' (dust marks) – he willingly complied, although drew the line at goodwill's suggestion of throwing extra dirt into the printing press.

experiment normally seems to be associated with analogue methods – the computer tends to discourage mistakes from happening because it fixes an idea before it has had a chance to develop.

Designers have also begun to recognise the way in which, as a visual language, mistakes can reduce the amount of decision-making. This is something that many approve of, having grown tired of the overwhelming degree of choice that digital programs impose on them. Equally important is the fact that mistake-making fosters individuality, something graphic designers are constantly striving for in order to escape the growing homogeneity of contemporary design.

88 IMITATION

Before computers became widespread, most graphic designers
wanted to achieve the high levels of finish that today are naturally
facilitated by the use of digital processes. In the early 1980s,
David James (working in London) used to execute designs by
hand with a degree of accuracy that created an effect similar to that
achieved by sophisticated computer manipulation. Some of his hand-
rendered music posters could easily be miscategorised as an example
of club culture-inspired design made possible by the ease with which
the Macintosh now enables layering, image manipulation and
distorted letterforms. Similarly, James' record covers for System
7's single 'Altitude' and album 'Water' now look as though they have
been generated in Photoshop, but they were in fact created entirely
in-camera during a complex, three-day photoshoot, each captured
within a single shot [7].

Since the effort and skill required in producing these kinds of
effects has been rendered unnecessary by new technologies, many
designers are wanting to reference old handmade processes or styles,
either to reintroduce a degree of challenge, or as a way of avoiding the
kind of look that is now so commonplace. But as designers often lack
the equipment, the budget, the time or the incentive to use these old
methods, so they have to come up with alternative techniques that
just mimic the effect [8–12].

Imitating letterpress

Despite being sneered at by devotees, graphic designers continue
to invent intriguing ways of imitating letterpress. Most commonly they
simply scan some original printed type then work with it on screen
[10], but some have adopted more elaborate techniques. One is a
fairly well-known method that consists of creating type on a computer
then transferring it onto a photo-etching plate. Peter Anderson has
formulated an alternative procedure that involves making a rub-down
of photocopied or laser-printed text using lighter fuel. He places the
page of text face down onto another sheet of paper, then covers the
reverse in lighter fuel and rubs over it so the type is transferred onto
the second sheet [p. 41]. London-based Sam Winston uses two black

7. System 7 CD cover
Design: David James,
London 1990
Produced in collaboration with
photographer Trevor Key, these
images for the single 'Altitude'
were created entirely in-camera,
each within a single shot.

and white laser printers. One of these printers is old and behaves unpredictably when thick paper is fed through it, distorting the type in such a way that it bears a closer resemblance to a letterpress print than a digital output. Winston occasionally exploits this built-in 'flaw' as a means of introducing slight inaccuracies [p. 70].

The concept of imitation is an interesting one, particularly when designers use a form of technology to produce effects that could be achieved more easily using other methods. For example, why did Mevis & van Deursen spend hours manipulating a poster to make it look as though it was the result of the careless use of a photocopier? [12] One obvious answer is that they are trying to fool their audience, but there also seems to be something inherent in many graphic designers that urges them to make things harder for themselves. Often this kind of effort helps generate ideas, but sometimes it is simply a case of people wanting to prolong their involvement with a particular process.

9. Spread from *Guidebook*
Design: Philip Atkins
and Michael Johnson,
Oxford 1999
The designers wrote, designed
and typeset this guidebook to the
architecture and history of the
colleges district of Oxford. At first
glance the text looks as though
it has been neatly hand-rendered,
reminiscent of Wainwright's
Lakeland Fells [p. 34]. It has in fact
been set in the Darjeeling family of
typefaces, designed by the authors.

8. 'Caterpiller' graphic
Design: Peter Anderson,
Gravitaz, London 1993
(photography: Platon)
For this Vivienne Westwood
publicity and advertisement
image, Anderson first created
the type on a computer, then
transferred it into an etching.
The etching was photocopied
to give it a higher contrast, then
scanned and re-worked on a
computer so it looked closer to
letterpress than digital type.

10. Exhibition poster
Design: John Morgan,
London 2000
The letters are scanned from
a letterpress type-design
catalogue then laser-printed
onto newsprint.

11. Designprice invitations
Design: Maureen Mooren
& Daniel van der Velden,
Amsterdam 2001
The invitations are designed
for an event including graphic
designers, fashion designers,
industrial designers and
architects. Maureen Mooren
& Daniel van der Velden made
a collage using design-related
text and picture cuttings from
newspapers and magazines,
changing the odd word to
relate it to the event. They
then printed the layouts onto
thin paper and organised the
information in such a way
to look as if it had been received
through a fax machine.

12. Fax poster
Design: Mevis & van
Deursen, Amsterdam, 2001
This poster was designed for
the Dutch artist Jan Rothuizen.
Mevis & van Deursen took a
piece of writing by the artist
and made it look as if it had
been heavily distorted by a fax
machine – but did so digitally,
by typesetting, laserprinting,
scanning and modifying.

FROM: JAN ROTHUIZEN AMSTERDAM NL. WITH: MEVIS & VAN DEURSEN JAN. 04 2001 05:08PM P1

Schitteren in afwezigheid, hoe voorbeeldig zou dat zijn, om steeds weer te schitteren in afwezigheid. Je ziet het voor je, hoe je niet binnenkomt op het feest. Geen mensen groet en alle blikken niet op jou gericht zijn. Je ziet hoe iemand je geen drankje aanbiedt en jij, geen gesprekjes begint met gezichten die je niet kent. Je ziet hoe je niet naar de nieuwe mensen kijkt die binnenkomen, zoals ze ook niet naar jou gekeken hebben. En je voelt hoe je geen onderdeel van dit feest aan het worden bent. Je ziet niet hoe grappig je bent, en drinkt terwijl je niet in vorm bent. Ook de grote klok zie je niet, met wijzers die draaien. Of de zon die ergens aan het opkomen is. Je hebt het niet in de gaten, want je bent er niet, en ziet niet dat de meeste mensen al thuis zijn als jij in de stemming komt. Schitteren in afwezigheid, hoe voorbeeldig zou dat zijn, om iedere keer weer te schitteren in afwezigheid.

92 COLLABORATION

In 1997, Max Bruinsma (then editor of *Eye* magazine), accurately predicted that 'within the broad province of the arts, design and visual communication, graphic design will remain recognisable as a discipline for some time to come. But it will merge more and more with the other disciplines' [M Bruinsma 1997]. Contemporary visual communication has become a complex mixture of design practices linked across a wide variety of media that encompasses print, television, film, advertising, internet, CD-ROMs, exhibitions and performance. As a consequence, graphic designers have become more closely associated with other practitioners, such as artists, illustrators, fashion designers, photographers and architects. The Netherlands are a particularly interesting case study in this respect. The population of trained graphic designers there is relatively large, so almost every piece of graphic has the luxury of having been designed by a professional working in a highly competitive market. The extreme level of competition, however, means there can be no specialised graphic designers – the only way they can support themselves is by doing a range of different kinds of design. The lack of specialisation results in different categories of design strongly influencing each other, and presumably explains the more immediate absorption of trends and novelties compared to other countries.

Engendering creativity

The point of all this in relation to handmade graphics is that an interplay between disciplines encourages graphic designers to think about non-digital means of production [13]. Stuart Bailey was one of twelve designers commissioned to design a film poster as part of an art project, each poster having its own specific title and brief. Bailey explains that because the job was designated as being 'for an artist', he felt like doing something unusual; he agrees this kind of scenario is good for generating ideas [14]. Keith Sargent of MMD (Mrs and Mr design) in London started working with artist Patrick Brill (formally known as Bob and Roberta Smith) in an attempt to rekindle his enthusiasm and creativity, having lost inspiration through the mainstream work he felt was tying him to the computer too much.

Jan Rothuizen

ON A CLEAR DAY YOU CAN SEE FOREVER

New York has thousands of hot dog stands and probably even more nail studios. On almost every corner, above shops, in the backs of obscure shopping centers, in subway stations everywhere, you can find places to get your nails done. Most establishments only do the manicures: they cut and smoothen edges and give nails a crystal clear polish for a healthy natural look. Among the black and Hispanic women it's popular to have little decorations applied to their glued-on plastic nails. These decorations are custom made and can feature a holiday painting, someone's name, but most of them are just very colorful decorations with shiny little stones, hearts and flowers. The nails you see are so elaborate and fine in detail that they resemble the illuminations monks made in the Middle Ages.
When I walk into Wonder Nails on Broadway with the cardboard sign under my arm all the girls who work there

13. *On A Clear Day You Can See Forever* (detail)
Design: Mevis & van Deursen, Amsterdam 1998
The idea was to take a classical book layout then copy it. For this book project featuring the work of artist Jan Rothuizen, Mevis & van Deursen first created a simple design with the type set in News Gothic. They made laser-copies of all the pages, then instructed the artist to trace all the type by hand so the book effectively became a 'sketch' of a book.

14. Film poster
Design: Stuart Bailey 2001
Bailey was one of twelve designers commissioned as part of a project by artist Ryan Gander to design a film poster, each with its own specific title and brief.

Sargent decided to use income from commercial clients to fund a publishing company that would enable him to set up his own projects. He has since worked on a series of publications with Brill, the highlight of which is their *A–Z*, a large-format bound book which was screenprinted and hand-bound in India [p. 122].

Art and design

In recent years the art scene has increasingly re-emerged as having an important role in graphic design. Today, there is a colossal amount of printed information produced about artists – often not just focusing on their work but also on themselves. Designers are employed to work on these publications, which gives them the opportunity to work alongside the artists; this has implications for both parties. For artists such as Atelier von Lieshout, the bulk of their work is represented via printed matter. Artist Ryan Gander proposed, 'if a text in a magazine or the image on a private view invitation adjusts the audience's reading of an artist's work, then surely it can no longer be regarded solely as support material, but must be regarded as an integral part of the work' [R Gander 2001]. Invariably, designers are keen to take on this responsibility, eager to be immersed in a creative, rather than a commercial, environment.

Fashion and design

Another obvious influence on graphic design is the fashion industry. Fashion, more than any of the arts, has, through its need to enhance and idealise the human body, always been an exercise in perfection, so there are interesting parallels to be made between this field and digital technology. Fashion designers have increasingly been experimenting with ideas that react against the pursuit of the ideal. Ann Sofie Beck uses painted or hand-dyed fabrics, slashing over stitching, hitching up T-shirts with safety pins, and customising shoes with masking tape or brown packing tape. Jessica Ogden similarly works with 'rough-and-ready' materials, referring to her work as 'portable art, one-offs that cannot be repeated.' Predictably, these methods have been quickly imitated by high-street fashion shops, and by fabric companies who now manufacture denim to give it a vintage, irregular look. Either

94 through their own exposure to the marketed product, or through contact with the fashion designers themselves, some graphic designers have been picking up on these ideas and have started incorporating them into their work [15].

Multi-discipline companies

The potential in these kind of relationships has encouraged practitioners to set up companies that see a variety of disciplines combined under one roof. Foundation 33 consists of two graphic designers, an architect and an artist. 'For a lot of our projects we don't really determine whether it's an art piece or a design piece,' explains founding partner Daniel Eatock. 'It's an ambiguous thing. It depends on the context in which it is being viewed.' Similarly, Ellen Lupton and J Abbott Miller in New York collaborate in both their art and design practice. And the name of their studio, Design Writing Research, refers to their work as designers as well as writers – this mix of interests is extended by their editorial and curatorial work on the history and theory of design in typography, graphics, art and industry [16].

That the merging of disciplines is a good idea has been proved by examples in the past, such as in the design of the Polish poster, in which art and graphics were hardly differentiated [p. 31]. Close communication between professions introduces an understanding that removes the inhibitions that invariably hinder the flow of ideas. Now that the information age is so well established, collaboration seems the obvious next step, giving people the opportunity to locate their work within new and potentially stimulating contexts. Grouping and sharing, and companies with horizontal rather than pyramid structures, are already being recognised as the most efficient and creative means of problem-solving.

The computer has both encouraged and discouraged these developments. It has become a universal tool for almost all Western professions, which has enabled universal understanding on a technical level – but people can only truly collaborate if they stop seeing the computer as a box on their desk that isolates them (like a television). There is also a certain amount of inherent antagonism

15. Publicity material for Jo Gordon Design: Huw Morgan, London 2000–2

Jo Gordon makes woollen accessories such as gloves, hats and scarves. She uses traditional methods, but combines this with a degree of quirkiness, deliberately trying to bring a human element into something quite conventional. Huw Morgan has produced various items for Gordon that echo this theme.

16. On/Off
Design: Design Writing
Research, New York 1999
This collaborative project – a set
of two photogravures entitled
On/Off – is an exploration in the
use of light to create letterforms.
The team created the images
using the luminous screen of a
computer, and then transferred
the digital images to films for
use in photogravure, an etching
process that offers extreme
tonal sensitivity and detail.

preventing this. Because of the nature of their work, graphic
designers are in the fortunate position of having access to a whole
variety of professions, but for people in other disciplines, the idea of
amalgamating their work with that of others is seen as more of a threat.
Photographers, for example, often express their disapproval of graphic
designers who take their own photographs, arguing – often legitimately
– that they lack the necessary skills and expertise.

INTERACTIVE

In the last fifteen years, design seemed to be more about sensation than about thought. Innovation has become a gimmick as the increasingly competitive market has promoted an attitude amongst graphic designers invariably characterised by an interest in achieving immediate visual impact, with a disregard for the long term. With their audience growing tired of this approach, designers are experimenting with reductive, rather than additive methods of working, as a means of encouraging readers to actually take notice of and think about what they see. There is a return to simplicity, but not to that of the old ideals of complete clarity and a lack of ambiguity. Today's approach is more about trying to minimalise a designer's personal design input, so as to allow the information to be presented in its rawest possible form.

The viewers' input

One way that designers are achieving this 'less designed' approach is by providing a framework for future actions outside their control, making the work reliant on the viewer's response so that without it, the piece is denied its essential 'content'. In this scenario, the original design may be something purely digital, but becomes non-digital by the user's interaction with it. 'A big thing in our head is the user,' explains Maureen Mooren of Maureen Mooren & Daniel van der Velden in Amsterdam, who have produced a whole series of publicity materials for various art galleries in the Netherlands that is based on the reader's response or interaction. So far their ideas have been developed furthest with the launch in 2000 of *Archis* magazine, where they devised an unusual format that offered the tools for interactivity, such as faxes that could be filled out by the reader and used, or tear-offs that worked as part of a game [p. 128].

Foundation 33's Daniel Eatock has an ongoing interest in the idea of creating design that has spaces for the viewer to 'fill', coming up with the motto: 'say YES to fun and function and NO to seductive imagery and colour!' [p. 130]. He has applied this idea to a range of material, particularly stationery, where interactive solutions are becoming increasingly popular as a means of avoiding having to reprint

17. Stationery
Design: Daniel Eatock,
London 2000
Eatock made this sheet of labels, based on VHS cassette stickers, to enable film-maker Louise Camrass to brand both her cassettes and stationery with elements from a single sheet — she could then add specific information herself by hand.

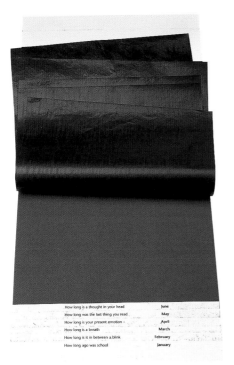

**18. Carbon paper calendar
Design: Sam Winston,
London 2001**
The recipient is instructed
to draw a line onto the carbon
paper in response to a question
allocated for each month – the
length of the line is supposed
to represent their answer.
The final page becomes an
abstract array of fine lines and
faint blue smudges.

How long is a thought in your head	June
How long was the last thing you read	May
How long is your present emotion	April
How long is a breath	March
How long is it in between a blink	February
How long ago was school	January

people's contact details, which nowadays change so often [17].
Other designers have come up with more unusual, or extravagant,
interpretations of the same concept [18].

Origins and implications

The idea of trying to involve the viewer as an active participant
originally derives from French philosophy and literary theory of the
early twentieth century, which encourages the deconstruction and
exposure of manipulative visual language and different levels of
meaning in a design. Colleges such as Cranbrook in the US first
started to incorporate these ideas into their deconstructivist and
postmodernist teachings in the 1980s, but today, graphic designers
are adapting them in less obtrusive ways, allowing the viewer to play
more of an active role.

For contemporary society, this interactive relationship between
designer and viewer is particularly well suited. An obvious benefit is the
economical one since, in effect, the designer only partially completes
the job, thereby saving costs and reducing waste. More importantly,
interactive solutions engage viewers in a way that encourages them
to think for themselves – something the advertising world has done
a surprisingly good job of preventing over the last few decades. What
is potentially even more concerning is the fact that advertisers are
already catching on to the idea of audience participation, finding ways
to manipulate it to their own advantage.

98 RE-USING

Given the vast amount of graphic design that now surrounds us, it makes sense to start re-using some of it. Increasing numbers of practitioners are doing just that, particularly in the light of relatively recent, but now widespread, concerns about the environment. The most obvious related change in the design industry has been the surge in the use of recycled stocks. London art director Nancy Williams describes how the pressure of environmental issues has had much to do with the resurgence in the popularity of old crafts and skills including paper-making and letterpress printing [N Williams 1995]. Some graphic designers are taking these concerns seriously, but in reality the majority, like everyone else, are simply following what has become fashion, or even a gimmick. Artomatic partner Daniel Mason argues that most designers use recycled paper just to communicate a message – 'not because they give a damn.'

Early examples

The idea of re-using, as opposed to recycling, is something graphic designers and artists have been doing for decades. Both are notorious for collecting odd bits and pieces and using whatever is at hand to bring into their work. In the early twentieth century, the Dadaists incorporated all kinds of waste material into their pieces, while the Cubists used bits of coloured or printed paper from newspapers, wallpaper and cigarette packets. Willem Sandberg, who was influenced by both these movements, printed many of his catalogues on used paper as a way of ensuring each one was unique. The eighteen volumes of his self-published *Experimenta Typografica*, consisted largely of the scraps of paper and scribbled notes he had collected whilst he was in hiding during the war. In a similar vein, British printer and typographer Guido Morris (working in the 1930s–50s) used to keep the leftover proofs from his letterpress work so he could recycle them for other designs [19].

Incorporating 'non'-design

For contemporary graphic designers, the incorporation of some ephemeral or 'undesigned' typography into their work has become a typical way of counteracting what has become an over-designed environment. The contrast between professional and non-professional

**19. Cover for *One Tree Singing*
Design: John Morgan, London 2002**
Morgan made a collage out of a Guido Morris print then scanned it to make a cover for *One Tree Singing*. The book is a collection of poems published as part of a project that attempted to demonstrate the beauty and versatility of wood by using all parts of a single oak. 'Our ambition is to show that careful use of timber can be of tremendous benefit to the environment both locally and globally,' say the directors of the One Tree project, Gary Olsen and Peter Toaig.

**20. Seminar poster
Design: John Morgan,
London 2001**
The seminar was about people's
personalities – and façades.
Unsuccessful in his attempts to
peel off a circus poster he spotted
in East London, Morgan tracked
down the suppliers, who gave
him an original. He then stuck
on a label with the seminar
details and scanned the lot,
deciding he was safe from
copyright problems given the
different audience the poster
would attract.

21. New Year card
**Design: Office of CC,
Amsterdam 2002**
The idea was to celebrate the
coming of the Euro and to say
farewell to the beautiful Dutch
bank note. The title was set on
a computer, then film was made
to produce an etching plate for
letterpress printing.

**23. Flyer for Performance
art event**
**Design: Micha Weidmann,
Berne 1996**
Weidmann ordered 1,000 pre-
printed dartboard cards, then
silk-screened the event
information over the top.

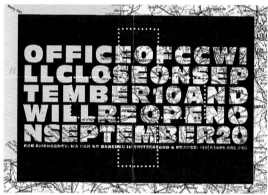

22. Vacation cards.
**Design: Office of CC,
Amsterdam 2001**
The cards announce a vacation
to Switzerland (represented by
the cross-shaped die-cut holes)
and France (represented by the
map). They are cut out from old
maps, then laser printed with a
percentage of black so the map
remains visible. The holes were
punched by hammering a thin
tube of metal through the paper.

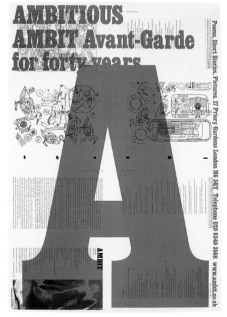

24. *Ambit* poster
**Design: John Morgan,
London 2001**
The orange type is printed
onto spare running sheets from
Ambit, a quarterly magazine
of poems, short stories and
pictures described by Peter
Redgrave as 'the foremost
organ of the lucid orgasm
party.' (Morgan also designs
the magazine.)

25. Stencil numbers
Design: Karel Martens,
Amsterdam, 1989
The numbers are letterpress
printed onto a page of newsprint
in a 'magic' formation, as found
in Vedic mathematics. A hidden
order is revealed and confirmed
visually through the consistent
colour system, with overprinting
playing a part.

design is often exploited as a means of achieving graphic impact
and of drawing attention to the blandness of digital design [20–5].
For Dutch graphic designer Karel Martens, working with used paper
including newspapers, postcode books and other used materials
that appeal to him becomes a way of conducting personal visual
research. 'His work is characterised by workmanship and simplicity,
not glamour,' concluded the jury who awarded Martens the Dr A H
Heineken Prize for Art in 1996. In other cases the design input
becomes more a process of editing than of creating images. London
art director Mark Pawson, for example, makes use of his own or other
people's waste material for an ever-growing collection of handmade
booklets and publications [p. 148]. Similarly, Paul Elliman's 'Bits'
typeface is made up of an ongoing collection of roadside
detritus he has been accumulating for several years [p. 132].

The growing popularity of this approach amongst graphic
designers again supports the argument that many are trying to escape
slick, computer-generated results. For designers who can recognise
the potential of a piece of graphic material within a different context,
this magpie aesthetic has become a way of reintroducing a sense
of individuality into their work that computers have to a large extent
removed. Desktop publishing has enabled graphic designers to own
a personal means of production that facilitates this kind of mix and
match approach, allowing them to combine recycled material with
computer-generated typography or images with complete flexibility.

DEFACING

The uniformity of digital type and the quality of modern reproduction creates an irresistible context for the inclusion of a vigorous, organic line. Letters are not governed by rules as typefaces are, and graphic designers are increasingly playing with combinations somewhere between the two, exploiting the contrast for graphic impact [29–35]. New York-based designer Tobias Frere-Jones recently wrote, 'for designers who want a non-modernist and individual portfolio, an illegible grunge typeface becomes a seductive method of self-identity' [T Frere-Jones in M Bierut et al 1997]. Design books such as Stefan Sagmeister's *Made You Look* and John Maeda's *Maeda@Media* demonstrate this particularly well, where the authors' hand-scribbled notes and sketches give the publications a more personal and 'authentic' feel. It is interesting to find one's eye drawn to these scribbles, despite the fact that they are less legible than the surrounding typescript [26–7]. For Sagmeister, this approach is reminiscent of much of his own work [p. 62].

Graffiti

The idea of applying crude, hand-rendered letterforms to digitally printed matter is commonly used as a controversial device. For example, the group of artists called Bank became renowned for doing this in the late 1990s when it came up with the idea of scribbling rude messages onto faxes to send back to pretentious art institutions [28]. Essentially this is a form of graffiti.

A term originally derived from the Greek *graphein* (to write), 'graffiti' means a drawing or scribbling on a flat surface – the word originally referred to marks found on ancient Roman architecture. Examples of graffiti have been found at sites such as Pompeii dating from the 1st century AD, in Rome and in Guatemala, but the activity is more usually associated with twentieth-century urban environments. As an illegal form of expression, to society at large it constitutes vandalism. During the last century, graffiti has developed from being just an urban, lower-class form of protest into something used by a wide range of racial and economic groups. And in recent years, it

26. Spread from
Maeda@Media
Design: John Maeda,
Massachusetts 2001
John Maeda has included his
own handwritten notes in some
of the layouts, which has the
effect of making the idea of
digital programming more
accessible and less intimidating
to non-professionals.

27. Spread from *Made You Look*
Design: Stefan Sagmeister,
New York 2001
The handwritten text throughout
Sagmeister's book comes from
a business diary he has been
writing since around 1990.

28. 'Fax-bak' Bank,
London 1999
Bank collected gallery press
releases, which they marked as
if they were student essays –
including a grade and comment
on their contents and graphic
presentation – then faxed back to
the gallery. The practice was the
product of a particular movement
that began to emerge in London
in the early 1990s, as part of which
independent, artist-run galleries
reacted against the commercial
or institutional artworld by
adopting a 'trash' or low-tech
approach to art.

29. Lou Reed CD cover
Design: Stefan Sagmeister,
New York 1995
The inspiration for this cover comes from the work of Middle Eastern artist Shirin Neshat. The hand-rendered lettering over Lou Reed's face was supposed to convey the personal, confessional nature of the songs. For the cover of an accompanying book, Sagmeister embossed hand-rendered words onto a photograph of Reed so that his face appeared to be scarred.

30. *Everything* magazine
contents spread
Design: Ruth Blacksell
and Stuart Bailey,
London/Amsterdam 1999
The designers used the original, sketched flatplan as a background image for the opening spread of the magazine.

31. Joe's card
Design: Studio
Myerscough, London 2000
Morag Myerscough spotted this bollard by chance at the top of Joe Kerr's road (someone she knew). She used the photograph she took of it on the reverse of his business card.

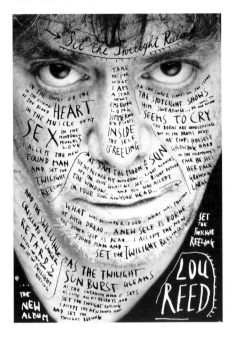

33. *Adbusters* cover
Design: Mike Simons,
Toronto 2001
Simons scribbled ruthlessly over an existing image with a black marker pen so it looked as though *Adbusters* had graffitied over someone else's magazine.

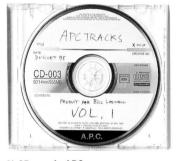

34. CD cover for APC
Design: Jean Touitou,
Paris 1995
Touitou scribbled the title, volume number and date of the album by hand onto a pre-printed blank CD, so that the generic CD 'stamp' becomes part of the design.

32. Title page
Design: Fraser Muggeridge,
London 2001
The author's scribbled notes, taken from the front page of the original manuscript, form the background image of the title page for *Art Crazy Nation*.

104 seems to have gained status on the street in the same way that hand-drawn script has gained status on the printed page. Both are developing more flamboyant styles and forms in reaction to their increasingly drab and homogenised physical environments.

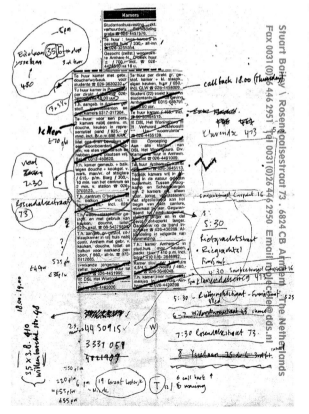

35. Moving card
Design: Stuart Bailey,
Arnhem, 2000
The image is a half-size reproduction of the cutting from a newspaper Bailey used to find a new apartment in Arnhem. The crossed-out entries are the places he visited, the circled one marks the eventual success.

36. 'Walls to Flag' Design:
Peter Anderson, London 2001
During a two-week installation,
Anderson transformed the
window front of a Lilywhite's
sports shop into Puma-related art.
The wall of trainers was designed
to make an anti-nationalist
statement, referencing positively
the way in which people form non-
geographical nations grouped
around particular interests,
hobbies or fashions – taking the
Puma brand as an example.
　　Anderson organised the
trainers into piles according to
their style, using them as spots
of colour to form an overall flag
image. He rearranged the piles
to create a new flag and wall
each day, using the front, middle
and back of the window space.
　　The idea was that the piles
of trainers in the background
would gradually be 'swallowed'
by those in the foreground, until,
by the end of the installation,
the foreground would be
transformed into a totally new
flag. The end result was a large
flag that filled the entire window
space, creating a 'Puma sports-
nation'. The shoes were later
cut up and made into a new
artwork for the Puma concept
store launch.

THREE-DIMENSIONAL

Just as the application of graphic design need not be limited
to a flat surface, so the process itself can involve more than two
dimensions. Computers have on the whole discouraged designers
from thinking in terms of three dimensions, mainly because of the
limitations of the interface. Digital designer John Maeda recently
wrote, 'it is unfortunate that the display technology of the computer
we use has been designed around the flat, rectangular metaphor
of machine-cut paper, instead of the unflat, unrectangular, and
infinitely multidimensional space of pure computation' [J Maeda
and N Negroponte 2000]. Until a form of technology evolves to
overcome these problems, it will remain far easier for graphic
designers to rely on analogue methods as a way of incorporating
a third dimension into their work.

Off-screen involvement

The practical implications of three-dimensional design work such as exhibitions, signage, packaging and so on, necessarily demand some non-digital involvement, so essentially force graphic designers to work off-screen. For designers such as Peter Anderson, working in three dimensions is as natural as working in two, and the methods he uses are determined simply by what he wants to achieve [36–7]. Other practitioners are increasingly following the same logic, coming up with ingenious ways of incorporating objects or model-making into their work as they recognise how it can be used to transform an ordinary piece of digital print into something more surprising or intriguing [38–41].

The three-dimensional aspect is one of the few things in graphic design that still demands manual involvement. The computer will never be able to offer a truly viable alternative, even if programs are developed that make it easier to transfer ideas from screen to a non-flat surface. It is usually obvious when exhibition graphics have been created entirely on-screen because they tend to look either dull or illegible. By avoiding conventional judgement about methods of production, and by exploiting whatever process is most suited to the idea, designers can use this kind of work as an opportunity to explore and discover new techniques which might have nothing to do with their everyday practice, thereby offering new sources of inspiration.

**37. Poles of influence
Design: Peter Anderson,
St Lucia 1999**
Anderson used wooden poles that he found littered over the island for a commissioned installation, as a way of unobtrusively expressing his own culture within the local context. Numbers avoided the problem of language barriers, so he selected certain dates that were significant only within British culture. He wrote these onto painted, wooden poles, then planted them around the entire perimeter of the island. The number and colour of each pole correlated with its position on the site. According to Anderson, the poles were interpreted as 'everything from voodoo icons to off-shore racing markers.'

**38. Identity scheme for 1508
Design: A2-GRAPHICS/
SW/HK, London 2001**
A2-GRAPHICS/SW/HK was commissioned to create both the name and a dynamic visual language for a company whose service is to advise and implement strategic communication and design. The concept is inspired by Buckminster Fuller's projection of the earth, a map created to achieve the most accurate visualisation of earth in two dimensions. Buckminster Fuller's projection has been used as a template to represent the five continents, which allows them to be arranged in numerous ways, enabling one location to connect and unite with another – a reference to 1508's global reach. The aim was to produce a flexible identity that could be easily shifted and changed across all applications.

**40. Human typeface
Design: Åbäke, London 2001**
As part of a design fair, the designers carried out a performance that involved imitating letterforms requested by onlookers (who could participate if they wished). They took polaroid snaps which they then sold.

**39. Knoll 3-D letters
Design: NB Studio,
London 2001**
The designers found these plastic letters in the Knoll furniture showroom, a set left over from a temporary installation. Having obtained permission to take them away, they proceeded to haul the letters across central London, where they took photographs of them in various different situations. The images were used for invites to the opening of Knoll's new showroom.

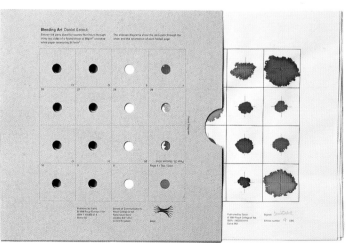

**41. Bleeding art
Design: Daniel Eatock,
London 1999**
Eatock folded an A1 sheet of paper into a square, then constructed a wooden block to hold 16 felt-tipped pens. He positioned the pens on top of the square then let them drain through the paper over a period of 24 hours so the ink could penetrate through to the other side, and when the paper was unfolded, the trajectory of each of the colours through it could be traced. Eatock made 300 copies of these sheets.

108 **LOW-BUDGET**

In terms of creative thinking, one of the drawbacks of digital technology, as discussed earlier, is the overwhelming degree of choice. Financial restrictions can therefore be useful. The lower the budget, the harder designers have to think to find ways of accommodating it, especially if they want to disguise the fact that something has been produced cheaply – and the harder they think, the more likely they are to come up with an original solution. British designer Herbert Spencer recognised this in describing the work of Willem Sandberg, which involved various techniques for printing economically, such as using the same half-tone block for printing a catalogue and a poster if they related to the same event. 'As so often in printing design,' Spencer writes, 'the impact of many of the dramatic effects in these catalogues is heightened by the economy of means by which they were achieved' [H Spencer 1960].

Alternatives to litho-printing

Litho-printing, although generally accepted as standard, is by no means always the most economical means of production, and even letterpress can be less expensive than litho for short-runs. Most forms of technology can be exploited more cheaply when the designer has a full understanding of the process, which is how Graphic Thought Facility manage to find ways to incorporate apparently extravagant processes into their work, for example in adapting electro-luminescent technology for their display signs at London's Science Museum [42]. For low-budget projects, designers are also more inclined to reject the computer and experiment with less conventional processes because the financial risks are lower, and because clients are usually more willing to take risks themselves.

DIY printing

Today, with desktop publishing, graphic designers have the opportunity to produce their own material both cheaply and easily. Almost any individual can have access to the means of reproduction, achieving a quality that is actually superior to most previous forms of commercial printing. This independence has only previously been

**42. Opposite and above:
Science Museum display
Design: Graphic Thought
Facility, London 2000**
The display is based on electro-luminescent technology, commonly used in devices such as mobile phones to light up a screen. The design of the letterforms demonstrates the constraints of the medium – each letter had to be continuous because with this technology there can be no breaks in an electric current. Having worked with technicians and learnt exactly how the process worked, GTF found by the end of the project that they had discovered solutions to certain problems that the technicians themselves were unaware of.

43. *BAT*
**Design: Io Grafix,
Barcelona 2000**

Io Grafix produced *BAT* as an
edition of 100 spiral-bound
booklets, using recycled and
copier paper with a perspex cover.
Printed in black only, it is a semi-
autobiographical visual story of the
work and life of Io Grafix from 1974
to 2000. She mixes analogue and
digital methods, using photocopies
of photographs, logos, symbols,
type and handwriting.

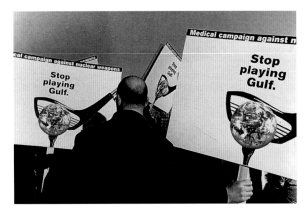

44. Film poster and flyers
**Design: goodwill and Stuart
Bailey, Amsterdam 2001**

The idea is based on a library
suggestion form that the
designers filled in with
information about the films. Later,
spotting a poster on a wall, they
decided to each make a drawing
of the character it depicted. They
took these along with the forms
to a restaurant, and having
experienced a moment when both
items were held up to a candle,
one behind the other, decided to
unite them. The films had to be
advertised in a design school the
following day – luckily, Mevis &
van Deursen's studio was on the
same street, and Bailey had a key.
Entering at about 11pm, Bailey
and goodwill used a photocopier
to make a series of different-sized
posters (to be arranged in order of
scale along a corridor). They also
produced a matching set of flyers
using the drawing of the mural
character on the reverse.

45. Gulf War posters
**Design: Peter Brawne,
London 1993**

Twelve copies of the globe were
printed in colour onto a single
sheet, then cut out and stuck
onto posters printed by a black
and white laser copier.

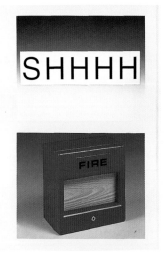

46. *Multiplication* catalogue
**for the British Council
Design: A2-GRAPHICS/
SW/HK, London 2001**

The catalogue is for an exhibition
of artists' multiples from the
1990s, all 2,000 copies of which
had to be produced within a
minimal budget. By undertaking
a substantial amount of manual
work, A2 transformed what
might have been an ordinary
publication into an expensive-
looking catalogue.

The pages are printed in
one colour throughout, except
for the colour plates, which
have been printed together
on a single sheet of paper. The
designers collated and tipped in
every image (47 per book), then
folded dust jackets onto each
one. (They also used three
types of paper, which multiply
in weight for the three sections
of the book: 50gsm, 100gsm and
150gsm respectively, for the
prelims, plates and endmatter.)

equalled by the likes of Alfred Wainwright, who was able to produce
the *Lakeland Fells* book series entirely on his own desk using one tool –
a fibre-tipped pen – for the whole publication [p. 34]. Designers have
been surprisingly slow to acknowledge the potential of desktop
publishing as a creative outlet, perhaps because they still question
its validity in relation to 'real' printing. Recently, some have started
to think more seriously about the idea, either producing work from
scratch or using desktop publishing as the most cost-effective way
of reproducing their analogue-based ideas [43–5, 47].

**47. Stationery
Design: Micha Weidmann,
London 1999**
Weidmann created a
typographic image for an
architectural practice
(Emulsion) that used repeated
capital 'I's to form the
background of their printed
identity. This graphic element
could be used by anyone else
in the same way, eliminating the
need for an individualised logo.
Everything was produced
on a laser-copier so that printing
costs were minimal and the text
details could easily be changed.
Emulsion could apply the
typographic system to other
publications, and actually used
the pattern to cover an entire
wall as a part of an exhibition.

Personal work

48. Opposite: Letterpress tray
Design: Jeremy Johnson,
London 1999–2001
This visual record of the entire
contents of a type tray is
designed to show the extent to
which fellow students were
replacing pieces of type in the
wrong compartments – for

example, a Helvetica bold 'g'
put back in with the Joanna
roman 'k's. The type in
Johnson's print of his record
of the misfiled characters is set
using the same grid as the tray.
Johnson describes the piece
as 'a systematic idea that
designed itself.'

SELF-INITIATED

It can be difficult to strike a balance between commercial and experimental work. Clients who are willing to take risks and commission unusual graphics are rare, and designers often find it hard to pick up the sort of jobs that allow them the freedom to explore their own ideas. Design writer Natalia Ilyin describes how graphic designers need to feel that what they create is individual, specific and inspired, but that they need to do so 'in a way that does not get knocked down at marketing meetings [...] restricted by a client's budget, and lack of vision' [N Ilyin in M Bierut et al 1997]. Working on their own projects may be the only way designers can escape the restraints of client-driven work, and avoid having to produce the kind of bland, lavishly produced and often overdone creations demanded by many commercial jobs.

Bespoke design

Marketing schemes aimed at the consumer who is increasingly frustrated with homogenised products are now offering a degree of 'choice', giving rise to the individual who dictates what they want. Martin Raymond, editor of *Viewpoint* magazine, describes how, 'the bespoke consumer is demanding a bespoke culture, which is in turn creating "one-off" fashions, furniture and graphic design.' The opportunity for self-expression and the creation of individual identity is now facilitated by digitisation through the internet, artificial intelligence, computer-aided design and so on that has, for example, led to architects such as Rem Koolhaas designing 'intelligent' shops that identify the shopping patterns of individual customers.

Time investment

Throughout the last century there have been enormous changes in people's attitudes towards time, and the amount people are prepared to invest in certain tasks. The notion of someone dedicating years of their life exclusively to a stone carving for a building façade would be inconceivable today, except if it was related to some form of self-expression. For some graphic designers, avoiding the computer is a way of allowing them to put time back into their work [49–50].

49. Sewing project
Design: Ben Chatfield,
London 2001
Chatfield experimented by sewing onto sheets of paper torn from an accounts book, attaching different materials that he found lying around. Chatfield then photocopied, scanned and silk-screened these collages, finally laser-printing the images onto adhesive labels, which he then applied to various objects.

50. Newspaper books
Design: Stuart Bailey,
Amsterdam 2000
Bailey began to produce his newspaper books when Dutch newspapers regularly started printing colour photographs on the front page. He collected and cut out the images every day for six months, intending them to act as alternative stock photography books. The images are composed with a strong central axis, so they lend themselves to the centrally folded format.

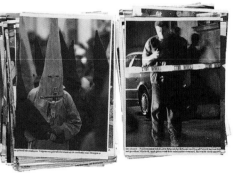

51. Black to blank
Design: Daniel Eatock,
London, 1999
Having installed a brand new toner cartridge into his laser printer, Eatock created a document on the computer that consisted entirely of a black page. He printed the page hundreds of times until the toner no longer left any kind of mark on the paper. Eatock was left with this stack of paper, which is about half a metre high and through which the entire contents of the toner cartridge is dispersed.

114 Foundation 33's Daniel Eatock goes to extraordinary efforts to do this, arguing that it is a way of giving value to his work [51]. On one occasion he and colleague Martin Anderson spent eight hours covering an entire blackboard with chalk as an installation at the Royal College of Art bar [52]. On another, Eatock decided to reproduce the entire English dictionary by photocopying each page onto an A4 sheet. The result is a handmade duplicate that Daniel considers to be more valuable than the original because of the time and expense spent producing it, and because of its inherent uniqueness.

Independent publishing

Desktop publishing has opened all sorts of doors for both designers and artists, allowing them to produce short-run publications that provide a platform for unadulterated commentary. Designers feel more inclined to combine the computer with analogue processes for these projects, where they feel unrestricted by the pressures of time or by particular attitudes towards their work. Rober Pallas Cardeal (working in Barcelona) describes his self-published magazine, *Enser*, as a graphic experiment that allows him to express his own ideas outside the realm of other digital design and advertising work that he does. This sporadically published, short-run publication provides Cardeal with a platform to explore gritty and low-tech production methods. He states that, 'there is an emerging trend in design to avoid perfection as a field for exploration.' Cardeal believes that in the face of globalisation, the value of diversity takes on more importance, which is why he deliberately changes the format and design for each issue [53].

Motives

Other graphic designers have different reasons for working on their own publications or projects. The main objective of Pierre di Sciullo's *Qui: Résiste* magazine is to explore the way in which written words are expressed visually. The first issues he produced himself using a photocopier, until he was then able to convince printers and repro companies to support him. For recent graduate Katrin Schoerner, currently working for Meta Design in Berlin, the incentive came from her dislike of the physical lifestyle of a graphic designer, and the sheer

**52. Blackboard
Design: Daniel Eatock
and Martin Anderson,
London 1997**
As an installation in the bar at the Royal College of Art, Eatock and Anderson covered an entire blackboard with chalk, not even allowing themselves to 'cheat' by turning the chalk on its side. The eight hours of work they put in (with the help of two volunteers) seemed to generate respect, as the piece remained untouched for three weeks.

53. *Enser* magazine
**Design: Rober Pallas
Cardeal, Barcelona, 2000–2002**
The magazines are reproduced
entirely by photocopying, then the
pages are cut out by hand, and
folded and stapled into booklets.
For the artwork, Cardeal avoids
the computer except to scan
illustrations and for final page

make-up. 'The techniques I
use are classic object-tools that
cause imperfections: toothpaste,
hairspray, ballpoint pens, little
toys, a fax, my feet…This way
I get a personal piece each time,'
he says. Cardeal thinks that
special effects made with a
computer are often used as
camouflage for a lack of ideas.

frustration she felt at having to spend so much time sitting at a
desk tapping a keyboard. Since 2000, Schoerner has been developing
her 'pack-kitsch bags' as a personal project, making the bags by
hand out of unlikely, domestic items such as hot water bottles or
colourful plastic cushions. 'It's like an excursion in graphic design,'
she explains, 'I am keen to experiment with interesting materials
and to find out how to transform existing things into something
new' [54]. For Susanna Edwards the reasons are sometimes more
personal [55].

Not all graphic designers produce this kind of work, but
those that do seem to fit into two main categories. The first consists
of those who have become exasperated by the restrictive nature
of their commercial work; the second includes designers who are
brimming with more visual ideas than they can incorporate into
their current jobs. The differences between them are significant,
but they do share one important characteristic in their rejection of
digital processes and their (either partial or full) incorporation of
analogue methods of production. This suggests that the computer
has somehow become associated with the idea of a lack of freedom –
surprising, perhaps, for a tool that was originally designed to offer
the ultimate flexibility.

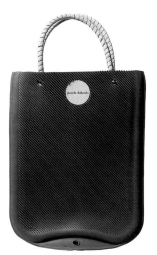

**54. Pack-kitsch bags.
Design: Katrin Schoerner,
Berlin 2001–2**
Schoerner started making a
series of bags, boxes, small
purses and cases at the end of
her degree course. This one is
made from a hot water bottle.

**55. Smashed ceramics.
Design: Susanna Edwards,
London 2000**
Following a break-up with a
boyfriend, Edwards decided
to take a set of cutlery to the
ceramics department at Central
Saint Martins and make casts
using clay walls and plaster.
Having completed the work, she
proceeded to smash the whole
lot – then felt a lot better.

116

SELF-PUBLICITY

One particularly prolific graphic designer whose work predominantly focuses on self-publicity is London-based Mark Pawson. His website (www.mpawson.demon.co.uk) offers a vast array of cheaply produced, handmade booklets covering every conceivable topic, including plug-wiring diagrams, eco-friendly logos, book-binding papers, and even a collection of paper badges – all of which can be purchased directly through Pawson by cash, cheque or credit card. He has sold up to 2,000 copies of the more popular varieties, which at around £5 a copy are earning him a small fortune [p. 148].

Johnson Banks in London is another design company that sees self-promotion as an important part of its business, allowing its employees to 'show off' their skills without compromise or constraints; it funds this kind of work with its relatively well-paid commercial work [57]. Similarly, in Amsterdam, Office of CC partners Chin-Lien Chen and Chris Vermaas allocate much of their time producing bulletins to inform their clients of their availability for work – and to maintain a good relationship, they even go to the extreme of issuing them with complaint forms. Chen and Vermaas typically use self-promotion as an opportunity to use non-digital processes such as letterpress, rubber-stamping and embossing [58–59].

Self-promotional work is not always initiated by designers themselves. For graphic designers who have reached 'celebrity status' this kind of work may be commissioned, in which case it typically calls for an adventurous response, which again encourages designers to reject conventional forms of production or image-making systems. Stefan Sagmeister has demonstrated this particularly well through his AIGA (American Institute of Graphic Arts) posters, where he specifically needed to come up with something surprising because they were aimed at an audience of designers [p. 62]. As well as providing themselves with the opportunity to work without the restrictions of a client's brief, these projects also allow graphic designers to demonstrate the potential for using non-digital production methods or processes.

**57. *Wouldn't it be Nice?*
Design: Johnson Banks, London 1998**
This twelve-page booklet is screen-printed onto thick card with three-dimensional images tipped in on each spread. It was followed by another version where each member of staff of Johnson Banks was presented as a chocolate figure.

**56. Box sets
Design: Susanna Edwards, London 2001**
Edwards was commissioned by London's Institute of Contemporary Arts to produce her own piece of self-publicity. The box sets she made contain digitally printed images and letterpressed information sheets relating to trips to Tokyo and Morocco. Edwards created repetitive patterns using photographs she had taken, then used woodblock type printed onto different papers for the divider sheets. Everything was then presented as loose sheets of artwork in transparent boxes.

58. Business cards
Design: Office of CC,
Mexico 2000
Intended for a traveller without
a permanent address, Office of
CC's Chin-Lien Chen and Chris
Vermaas gave verbal instructions
to a Mexican printer on a square
in Mexico City to produce 150
of these cards using lead type
to letterpress the details onto
thin sheets of wood. Several
versions were printed with
different job descriptions.

Clients are often reluctant to try experimental approaches, but are
more convinced by seeing examples that work in another context.
When this work is uncommissioned, however, a fair amount of time,
dedication or financial resources are usually required in order to
produce it – and few graphic designers find they have either the
incentive or the motivation to do so.

59. Complaint forms (2000)
Design: Office of CC,
Amsterdam
The layout was created on
a computer then laser-printed
and photocopied onto coloured
papers. The perforation was
made using a pattern cutter
used by dressmakers, the
corners cut by hand using
scissors and the numbers
rubber-stamped.

118

ISBN 90-6450-212-9

Catalogue for Riverine project
(Amsterdam 1994)

This catalogue was produced for a group of architects who attended a three-week workshop that took place on a cruise. Mevis and van Deursen designed it by imagining they were having to do so on the boat itself, with all the restrictions that would entail.

The layouts were made by tearing out and cutting-and-pasting images and texts that were then scanned and printed using a laser printer. The designers deliberately limited themselves to the restricted palette of colours available in laser-copying, and tried to make the whole thing look as 'undesigned' as possible. The hard copies were supplied to the printer as artwork rather than digital files, so the material's low resolution and clearly visible dots became part of the design, suggesting something crudely and cheaply produced. The cover was screen-printed onto canvas to imitate a boat's sail, the rough material and effect it has on the ink giving it a similar feel to the inside pages.

Armand Mevis describes how the design was criticised by the architects, probably because it was made when people were almost exclusively convinced only by slick, computer-generated solutions. If the designers had produced something similar today, the response might have been different.

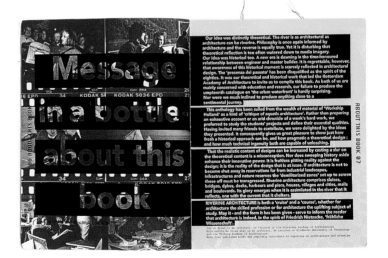

Eric Wear

Ten Days in the Mountains
(Hong Kong, 2002)

Eric Wear describes the text in this book – which he compiled, wrote and designed – as 'a fanciful travelogue for imaginative children (and their parents) to accompany an elegantly illustrated seventeenth-century Chinese album.' He writes, 'my ambition in writing this has been to create a book for both parents and children that allows them to enjoy a fine object in the spirit of traditional appreciation. The ideas and word images in the "ten days" recall Chinese poetic thinking but with contemporary flavour.'

The core of the book is an album by Xiao Yuncong, a significant Chinese painter of the late Ming and early Qing Periods. The original album followed the traditional style of its time, consisting of paintings that were individually tipped in onto pages of handmade silk. Wear scanned the sheets of silk and worked closely with his printers to produce a kind of facsimile that looks incredibly realistic. Rather than creating a direct copy of the original document, however, he invented his own new words and incorporated other features that bring the work into a modern context.

In addition to the texts that face the illustrations, Wear includes a discussion on the pleasures and manner of keeping such an old album. This authentic and yet contemporary introduction to classical Chinese taste is of a kind that has never before been available in either the West or in China.

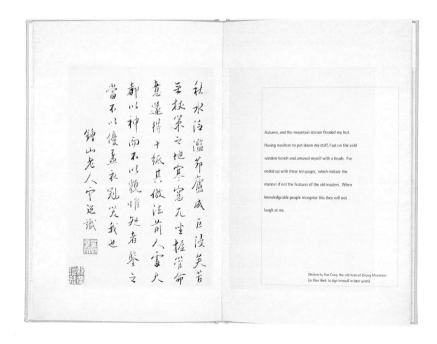

122

A–Z (India, 2001)

In 2000, Keith Sargent started working with artist Patrick Brill of Bob and Roberta Smith on a series of projects that began with digitising Brill's hand-drawn alphabet to create the typeface 'Inconsistent'. *Counter* was the first iMM print publication – an A5 catalogue of artists' work, including that of Bob and Roberta Smith. (There was no design fee for this job and even the paper was supplied free of charge by the manufacturers.)

In December 2000, Sargent travelled with Brill to India to produce *A–Z*, a 26-page full-colour A2 book that showed the new Inconsistent type's alphabet. The idea was to sell the books in order to finance other work. Having agreed to screenprint the entire thing, Sargent and Brill worked out that it would be more economical to fly to India, where the process is still commonly used and thus much cheaper than in Britain. They bought paper from Bangalore, then worked with a printing company in Mangalore who silk-screened the book [above, right], printing an edition of fifty, which were then bound by The School Book Company (also in India).

Sargent describes how the trip to India and being part of the whole production process had a big influence on the book's content and design (most of which was done on-site). This can be seen by comparing it with this local children's book [above, left]. Sargent thinks the difficulties of communicating with the Indian printers and binders imposed restraints that probably benefited the design.

In the Dark: Images and Text
(London 2002)

The phenomenon of the digital camera has shaken the foundations of the film industry. In addition to cheaper costs, digital video offers an immediacy and intimacy in both production and distribution that conventional film cannot. In his book *In the Dark*, director Mike Figgis explores the approach to cinema applied to four of his films. In one, *Hotel* – made only with affordable digital cameras – the actors improvised a surrealist drama about a Dogme film crew in which the director is assassinated by the producer.

The Danish Dogme 95 collective expressed 'the goal of countering certain tendencies' in contemporary cinema. It focused exclusively on the process – 'the making of' – rather than the afterlife of film, expressed by PR and marketing. In 2001, John Morgan developed a set of Dogme 95-style rules for a book design project he organised for graphics students at Central Saint Martins. True to the spirit of Dogme 95, Morgan's rules were aimed at focusing on the design process rather than the end product.

Collaborating with director Mike Figgis on *In the Dark* gave Morgan the opportunity to put into practice some of these ideas. Morgan's approach echoed the spirit of Figgis' work: the designer was to be invisible, his job to record but not to influence the author or subject.

Morgan allowed the book to design itself: Figgis' coloured scripts and notebook pages were reproduced in their original form, and any additional notation was handwritten by Figgis directly onto the page layout. The stills were grabbed using a DVCAM playback unit and exported from Adobe Premier to Adobe Photoshop as single frame 72dpi images – too low in resolution for lithographic printing. Figgis produced contact sheets on his Epson ink-jet printer, and after numerous trials of papers and output settings Morgan decided to use these as the originals for high-end scanning. The post-production route of producing higher resolution images would have been expensive, and the ink-rich prints had their own distinctive quality.

John Morgan

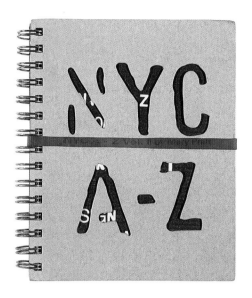

NYC A–Z (New York 1996)

Zurich-based art director Stacy Müller came up with the initial concept for *NYC A–Z* including the die-cut logo, while Mary Pratt (a photographic producer) sourced and compiled the contents, which encompassed doing everything from creating layouts in Quark to colour-copying alphabet soup [below, right].

Pratt handmade the first edition of 100 guides [opposite] – cutting, pasting and photocopying the pages. The die-cut was made by an old man in Brooklyn, the rubber band was hand-stamped (as were the 4,000 each for volumes 2 and 3) and the booklets were collated and ring-bound on a vast assembly-line table. Having received confirmation that volume 2 would be published, Pratt decided to team up with Swiss graphic designer, Nina Heller. 'I was reluctant at first to let someone else design it, but at the same time I knew she would be able to add so much to the book,' Pratt explains, 'it turned out that we worked incredibly well together.' Heller describes *NYC A–Z* volume 2 as an 'art book', made up of collages of found fragments and photographs taken by herself and Pratt [above left and right].

Maureen Mooren & Daniel van der Velden

Archis (Amsterdam 2000–2)

Described by editor Ole Bouman as a magazine about debate, *Archis* seemed like a good opportunity for Maureen Mooren & Daniel van der Velden to create something interactive. They wanted to try something experimental, so they came up with a format that responded to Bouman's ideas, creating pages that could work like a tool kit to accommodate a wide range of material.

Each of the five sections begins with a divider page showing the contents of that section, and every page of the magazine is perforated so it can be torn out and filed. The case studies consist of articles that imitate the design style of other magazines that have previously featured the piece – these magazines are credited, but otherwise no copyright is cleared.

In the first issue of the new *Archis*, some of the pages were designed as faxes that could be filled in, to encourage readers to send feedback to the editors. Other pages enabled readers to have 'conversations' with each other, as one magazine would often be read by more than one person. In issue 4, Maureen Mooren & Daniel van der Velden designed a page that could be used by readers to design their own T-shirt (which some duly did). Later editions included a perforated bottom panel, which could be torn out as a flyer or to form part of a game. The example shown [below, right] was designed to represent African money.

Initial reactions to the redesigned magazine were mixed. 'We were even receiving hate mail,' describes Maureen Mooren, who says they have since tried to give *Archis* a more suggestive rather than prescriptive visual tone.

ARE WE STILL LEARNING FROM THE BAUHAUS

Defining user profiles makes it much easier to take a
design process. This leads to a better insight into the
the infrastructure and the location, global and local
erative element in the design. The programme, that
get by with stepping up urban intensity by means of
balance between the economic forces of the city and
scenarios. As a design instrument, this thematic scen
matically integrate the spatial practices and hybrid, i
for forming the cultural identity of new communitie
acquires a spatial character through the theming. Th
and developing these scripted spaces. The different
to the design process. The result is an urban networ
that works not just through form but also through
ary experiences, these atmospheres offer every indiv

Perspectives

The radical transformation of the spatial organizatio
mentation and differentiation of the social space. T
face up to the complexity of the situation. The Bau
mix. Interdisciplinary research by those working in t
insights into the design process and make it possible
expand their repertoire of design strategies with sci
their visual skills to the planning. It is a way of work
own methods and to be receptive to different persp
ization of the work process and facilitate new forms

I would like,

As a gift,

From: Archis 4/...

Counterfoil

Archis

Yellow Folder
Research

Insert
T-shirt for
victims of sudden
success

Type

Size M

Photo Julius Rudolfus

Thanks to
NL Architects

From: Archis 4/2001 — 17 — Research

Mental exercise

Find the doors to Europe: Gibraltar and the Suez Canal.
Indicate on the map: Fortress Europe – Ceuta and Melilla.
Where is the 'Heart of Darkness'?
Cities on the Move: where is Lagos?
Import and export – ebony & ivory: locate the Prada branches on the map.

Archis 1

Archis 1
Layout Business in Africa

Text Ambrose A. Adebayo

Toolbar
The map of African

The streets of African
A search for identity and
sustainability

22
Research

23

Flyer

B u s i n e s s

as a unique cultural artefact in that it both
symbolically expresses the social relations
which structure people's lives and physically
functions as a spatial system. This seems to
have been the case in the traditional
African cities, regardless of their scale and
level of sophistication.

Islamic cities
Islamic cities existed as far back as the sev-
enth century AD and can be found in many
different parts of the world such as Spain,
Syria, Asia Minor, Iraq, Iran, Central Asia,
the Indian subcontinent, North and North-
West Africa. One cannot expect the urban
life in these places to have taken the same
form given the differences in national char-
acter, physical environment and climate,
and the different inheritance and involve-
ment in various commercial systems.[1]
The form of Islamic cities was influenced
to a certain extent by Islamic law and reli-
gion; other influences were economic,
through trade and commerce. Such influ-
ences are evident in the spatial organiza-
tion of these cities. In the case of Marrakesh
in Morocco, for example,[2] the built-up
areas within the city wall were concen-
trated around the mosque and the central
market, both of which are an extension of
the residential area and linear in form,
characterized by different geometric or
organic forms. This articulates contrast in
aesthetic and functional qualities of the
city. The commercial streets are called
Bazaar Street or Souk and consist of shops
and workplaces on the ground floor with
residential accommodation above. These
social and economic activities are located
in the heart of the city, an integrated organ-
ic form in a mixed-use dynamic urban
environment. The spatial organization
within the residential setting reflects a sep-
aration between the public and private
domains. The private spaces of the houses
are inward-oriented towards a courtyard
and not towards the street as in the case of
the public domain. There is also a clear ter-
ritorial division along gender lines in line
with Islamic culture.
The uniqueness of these cities – the legi-
bility, structure and character of the urban
form/system – is a direct response to and
thus reflection of the Islamic socio-cultural,
religious, economic and climatic factors
that have determined the physical form of
the city. In addition, due to dynamic cul-
ture, there emerges architecture that
respects the contextual vocabulary of the

built environment as one moves from one
place to the other. All this is achieved with
an understanding of the architectural
process, construction materials and
methods of community participation and
self-help.

Market towns and cities
The early East African seaports developed
as coastal commercial nodes because of a
long historical significance as centres of
trade with Arabia, China, India and the
Persian Gulf and, from the late fifteenth
century, with Portugal. Some of these
coastal towns, such as Mombasa, Lamu,
Zanzibar and Mogadishu, were influenced
by the cultures of the foreign traders. The
layout of these trading towns reflected the
commercial activities, the coastal location
and environmental and climatic factors.
The combination of residential and com-
mercial components resembles that of the
bazaar streets found in the Islamic city.
However the architectural details and deco-
ration are an amalgam of Arabic, Asian and
indigenous characteristics. This multicul-
tural architecture and spatial form is collec-
tively referred to as 'Swahili architecture'

*Given the local differences it is
inconceivable that urban life
throughout the continent should
have assumed the same form.*

and symbolizes a combination and unifica-
tion of varying cultures.[3]

Colonial Cities
The colonial cities in Africa were estab-
lished in line with the concepts of the colo-
nizer of the original cities. Certain architec-
ture and morphological features can be dis-
tinguished from one city to another. For
example, Harare and Nairobi, established
along British lines, differ from the
'Portuguese' cities of Luanda and Maputo.
French influence can be detected in Dakar
and Abidjan, while Windhoek and Dar-es-
Salaam display German characteristics.
These cities' urban management and the
legal and administrative systems are differ-
ent, as are the town planning codes. David
Simon explains[4] that the emergence of

colonial cities can most usefully be distin-
guished in terms of local factors such as the
period when the initial structural formation
took place, as well as the population, the
political economy and the ideology of col-
onization in the specific context.
The elements that determined the evolv-
ing nature of the relationship between the
Europeans and Africans are reflected in the
urban form of African cities in various con-
texts as a result of economic and commer-
cial control over existing settlements and
the ambiguous relationships between the
two populations of colonizers and indigen-
ous people. The physical structure and form
of colonial cities that existed side by side
with indigenous towns as dual cities was
often destroyed, ignored or absorbed into
new urban planning schemes that entailed
the separation of neighbourhoods by buffer
zones and formalized segregation. Colonial
cities' spatial form was, and in some
instances still is, characterized by social and
spatial segregation – structural inequalities
which reinforce racial and ethnic cultural
differences.
The cultural dominance and imposed
concepts of the various European coloniz-
ers, and planning principles based on mod-
ern movement ideals of mono-functional
zoning, contribute greatly to the problems
of today's cities. Specific urban elements
such as social centres, and recreational
areas such as central and neighbourhood
parks, have lost their original meaning and
identity and become breeding grounds for
crime. The central park in Nairobi, for
example, is located in an area where it is
only utilized during the day, and where it is
unable to interact appropriately with its
neighbouring, mostly commercial, areas at
other times. Maputo's central park on the
other hand is well situated within a resi-
dential and mixed-use area and therefore
lends itself well as a focus of social activi-
ties and recreation. Neighbourhood parks in
Durban, South Africa, are situated in areas
where houses are served with self-sufficient
residential gardens that render the demand
for such parks negligible. While such parks
contribute to the visual quality of the living
environment, they no longer function as
social and recreational areas.
One of the major problems of colonial
cities is that the city core functions as the
business, commercial and administrative
centre and lacks integration with other
activities in the city. Christopher Alexander
argues[5] that city functions need to overlap.

130

BIRTHDAY CARD

Before giving card, tick box or specify
which birthday is being celebrated.

☐ Eighteenth ☐ Fiftieth

☐ Twenty-first ☐ Hundredth

☐ Fortieth ☐ Other*

*Please specify

↑ THIS WAY UP

CASH CARD

Before giving card, insert cash/cheque and
specify the amount below with a tick.

○ £1 ○ £50

○ £5 ○ £100

○ £10 ○ £200

○ £20 ○ Other*

*Specify amount £

↑ PLACE THIS WAY UP ON MANTLEPIECE

UTILITARIAN POSTER / APPLICATION # 01

A SELECTION OF COMPLETED UTILITARIAN POSTERS SHOWING THE FIRST APPLICATION & COLLABORATION. THE RELEVANT INFORMATION FOR THE LIVE MUSIC EVENT WAS APPLIED TO THE POSTERS BY AROUND 40 ILLUSTRATION & DESIGN STUDENTS.

'Say YES to fun and function and NO to seductive imagery and colour!' series (London 1999–2)

In 1999, Foundation 33's Daniel Eatock worked on a project that explored the structuring of posters and the hierarchies they follow [opposite and below left]. He screenprinted 100 blank posters onto newsprint, then gave these to other graphic designers and illustrators to complete. The newsprint was intended to encourage people to write or draw on them.

The following year Eatock designed a set of eight greeting cards [above], silk-screened in a single colour onto uncoated brown board. His motto, 'say YES to fun and function and NO to seductive imagery and colour!' is printed on the back of each card. 'These things are incomplete,' explains Eatock, 'they rely on a second person, not the designer, to add something to it.' The Eatock family Christmas cards work in a similar way [below]. The surnames of all the people who receive the card are printed so each recipient can be marked with a tick. The recipient's Christian name is then written inside, and the cards individually signed by each member of the Eatock family.

SECTION THREE

Specify for which family member/s the card is intended

01	02
03	04

For instances where there are more than four family members continue list on back of card in the space titled Further Information

SECTION FOUR

This card has been authorised and is endorsed by the following members of the Eatock family (please sign)

Raymond	Carole
David	Charlotte

This greeting card has been specifically designed and produced for use by Ray, Carole, Dan & Charlotte. No other person/s are eligible to send or duplicate this card.

Quality control check / date

UTILITARIAN (DELETE AS NECESSARY) ADVERTISEMENT/ANNOUNCEMENT/BULLETIN/DECLARATION/PROCLAMATION

THIS POSTER PROVIDES A FRAME & STRUCTURE FOR THE INFORMATION & DETAILS FOR ANY EVENT/HAPPENING
COMPLETE THE EIGHT SECTIONS BELOW USING ANY METHOD OR MEDIUM
CONCEPT & DESIGN COPYRIGHT DANIEL EATOCK 1998 SAY YES TO FUN & FUNCTION & NO TO SEDUCTIVE IMAGERY & COLOUR!

TITLE

DESCRIPTION OF EVENT/HAPPENING

DATE

TIME

DIAGRAM/DOODLE/DRAWING/IMAGE/PAINTING/PHOTOGRAPH/SCRIBBLE/ETCETERA

LOCATION/ADDRESS

DIRECTIONS/MAP

FURTHER INFORMATION

IF YOU WOULD LIKE COPIES OF THE UTILITARIAN POSTER FOR ANY FORTHCOMING EVENT/HAPPENING CONTACT:
DANIEL EATOCK/SCHOOL OF COMMUNICATION DESIGN/ROYAL COLLEGE OF ART/KENSINGTON GORE/LONDON/SW7 2EU/UNITED KINGDOM
TELEPHONE + 44 171 590 4444 EXTENSION 4311/FACSIMILE + 44 171 590 4300

POSTER COMPLETED BY

Bits typeface (New York 1995–2002)

Paul Elliman has taught at Central Saint Martins, the University of East London and the University of Texas at Austin, and is currently Assistant Professor of Graphic Design at the Yale School of Art. He is self-trained.

Elliman depends on everyday objects for many of his ideas. Embracing error and inconsistency, he is able to discover ideas where other people see junk. In 1991 his electronic journal *Box Space* (which utilised the fax machine and e-mail) earned him a Gold Design & Art Direction award. Elliman describes how he has never felt the need to have a vast output, which is partly why he found himself increasingly drawn toward education during the 1990s.

In 1995, following a teaching project with students at Yale University, Elliman began to work on his typeface, 'Bits', a project that has been ongoing ever since. Bits is constructed from roadside detritus, including old pieces of metal, plastic, perspex and wire that Elliman collects then scans into the computer to create letterforms. So far he has produced over 200 characters.

In his article 'Other spaces', Rick Poynor describes how Elliman occupies a position both inside and outside design. 'Elliman's work shows none of the formal obsessions that have dominated graphic design's experimental wing for the past ten years. Elliman isn't indifferent to form and he doesn't want it to let his ideas down, but it doesn't drive him,' writes Poynor [*Eye* (Summer 1997) vol. 7, no. 25].

Logo for Code Red (Amsterdam 2001)

Code Red was set up to create a platform for new musicians and experimental music. One of the members had quite traditional ideas about what he wanted in terms of a look for the group, and requested that goodwill should design a Code Red logo. Following his frustration at having to produce what he considered to be an unnecessary and inappropriate form of identity, goodwill came up with a solution that involved printing the words 'Code Red' in black only, then afterwards underlining it by hand – always in red. This semi-hand-drawn identity means that no two versions can be exactly the same: a deliberate undermining of the corporate concept. It even works for high print-runs. For a Code Red magazine advertisement [opposite], goodwill laid out a page with a set of instructions encouraging the reader to do the underlining of the group's name, saving him the task of labouring through a pile of 5,000 copies.

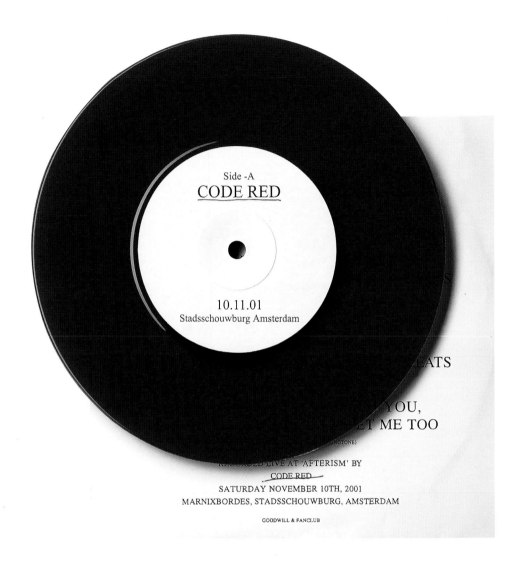

ON THE
4TH OF JULY,

CHINEES
VIJZELSTRAAT
AMSTERDAM
FROM 7 O'CLOCK

CODE RED

001. CRCD.
001.1 ULI ZITTEL,
PARRAPPA 5.
001.2 DDAMAGE,
*MAIBAN .**
001.3 GOODWILL,
DANCE OF A THOUSAND QUILTS.
001.4 HYPO,
PARIS-ROUBAIX.
001.5 DJSPIRAL,
TRONICA TRIBE.
001.6 KODI,
CREATE YOUR OWN LEGEND.

*FEATURING REIKO UNDERWATER. SPECIAL THANKS TO JEAN LOUIS MORGERE (NORSQ).
ALL TRACKS HIFI, 001CD. EDITION 500.
ALL TRACKS [20P]. WWW.CODE-RED.NL. (COPY-BURN).
DESIGN BY GOODWILL.

IMPORTANT: PLEASE READ THE LICENSE BEFORE BREAKING THIS SEAL
AND/OR USING THE SOFTWARE. BREAKING THE SEAL MEANS THAT
YOU AGREE TO THE TERMS AND CONDITIONS OVERLEAF.

[DISCLAIMER]
CODE RED WILL NOT DISRUPT YOUR SYSTEM.
WE ARE USER FRIENDLY PUBLIC BETA'S.

CODE RED

UNDERLINE WITH RIGHT HAND

CODE RED

UNDERLINE WITH LEFT HAND

CODE RED

UNDERLINE FROM RIGHT TO LEFT

CODE RED

UNDERLINE WITH EYES CLOSED

CODE RED

UNDERLINE WITH PEN IN MOUTH

CODE RED

UNDERLINE, MAKING THESE TWO WORDS MORE NOTICABLE THAN ALL OTHERS

PLEASE USE A RED PEN.
SEND ALL ENTRIES TO CODE-RED.NL FOR IMMEDIATE PROCESSING BY OUR GRAPHOLOGIST
ALL INFORMATION WILL BE WITHCLOSED TO AN EXTERNAL ADVISOR WHO WILL COMBINE A PERSONAL PLAYLIST.
FREE OF CHARGE

M-Real magazine (Helsinki 2001)

M-Real is intended as a forum for ideas loosely based on the Visual Perceptions course in the Psychology department of the University of Helsinki. It is a contract publication distributed via databases so it avoids being driven by advertising or sales, meaning that art director Jeremy Leslie has an almost free reign in commissioning artwork and articles.

Editor Jan Burney describes M-Real as, 'delving into the essence of consciousness, learning about the cutting-edge of response research and discovering how to make magazines irresistible on the news-stand.' The Response issue (or 'Logo') is the fourth in the series, following previous issues on Light, Colour and Words. For the design, Leslie commissioned another design company – New Studio – to work over his own layouts in response to each of the articles. New Studio simply overlaid each one with tracing paper, then scribbled mildly anarchic doodles on top using pencils, marker-pens, Tippex and biros. The process refers to former methods of magazine production, where images were literally layered over type that was set by the printers. The 'Response' cover is hand-drawn and refers to a list (taken from an article) of the 'dos and don'ts' of designing the covers of consumer magazines.

Leslie has worked in magazines for seventeen years. He believes that the return to older methods of magazine production is a resurrection of the Punk ethos of the 1970s, when low-grade methods were used to make things that were both spontaneous and instantaneous.

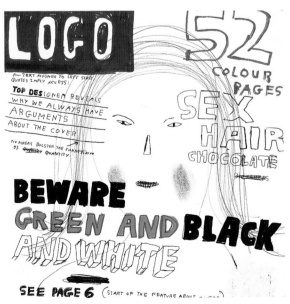

Catalogues for Habitat (London 2001–2)
Habitat's Autumn/Winter catalogue 'BasicDeluxe' [opposite (detail)] claims to be more about an attitude than about a collection of objects. 'It's a way of looking at the world, demanding luxury in the everyday and saying that mundane tasks need no longer be shabby or dull,' say its editors. GTF responded instinctively to Habitat's brief by photographing the collection in an ingenious way: they constructed a five-sided container – four sides of which were made from mirrors – then photographed each object inside it. The mirrors have the effect of distorting the sense of scale and lending the objects a mysterious quality.

The inspiration for the Spring/Summer edition comes from a villa in Southern France called Noillés, with which the Surrealists had links in the 1920s. Here the theme is about mixing styles and the idea of trying to create something that looks as though it has not been made entirely by machine. GTF made several cardboard models of spaces in and around the villa which they photographed – images of the actual Habitat objects were then superimposed (in Photoshop) on top.

GTF's Paul Neale realised not everyone would notice these background scenes were handmade, but the catalogues were aimed at the kind of audience who might.

Jeremy Johnson

squared version

regular version

italic version

bold version

2c typeface (London 1997–8)

2c, or 'two character', started as a typeface design project while Jeremy Johnson was studying at the University of Brighton. The initial idea came from experimenting with two shapes made from MDF sprayed with car paint. Johnson translated these into the basic forms of a sans serif character – the curve and the straight line – adapting the idea behind Herbert Bayer's universal alphabet. By creating an outline version of each form in the computer program Freehand, he combined these in various ways to produce each letter of the alphabet. Johnson also proposed a third shape be used if capital letters were required.

The typeface is supposed to be versatile, allowing users to design their own character shapes by mixing weights, altering the ascenders and descenders, or changing the widths and type styles. Johnson suggests that the tactile and moveable physical set of shapes might be useful as a learning aid, helping with spelling and understanding letterforms.

Sweden Graphics

**KPIST CD for MNW Records
(Stockholm 2000)**

Sweden Graphics were given complete freedom to design the covers for KPIST's album *Golden Coat*. They began by printing the CD sleeve as cheaply as possible in one colour. Then, kitted out with overalls, mouth filters and two spray cans of gold paint, the designers spent five hours spraying 2,000 covers in the record company's garage.

Sweden Graphics' Nille Svensson says that the process enabled them to express feelings of spontaneity, uniqueness and personality. 'Currently there is a trend of anti-aesthetics where the shabby and seemingly unsophisticated is favoured,' he says, 'this is easier to express with dirtier, more hands-on techniques. But at the same time a lot of people look for a really explicit computer aesthetic, and therefore all methods can co-exist.'

An exclusive set of twenty covers were sprayed with silver. These granted free entrance and back-stage admission to a series of KPIST concerts.

KPIST GOLDEN COAT

144

C C

with compliments

CUBITT
Gallery and Studios
8 Angel Mews
London N1 9HH
T +44 (0)20 7278 8226
F +44 (0)20 7278 2544
E info@cubittartists.org.uk
www.cubittartists.org.uk

**Stationery for Cubitt Artists
(London, 2002)**

A2-Graphics/SW/HK was commissioned
to create a new identity for the artist-run
organisation Cubitt Artists, following its
move to a former printer's workshop in
London. The solution had to be cost-
effective, easily reproducible (for purposes
of archiving) and flexible.

The designers came up with a simple,
monochrome identity that is supposed to
be authoritative yet human, thus reflecting
the character and individuality of the
client. The basis of the design is the use
of a selection of letterpress Cs that A2
scanned from an original print then applied
to each piece of stationery – the type range
was a reference to the recent history of
Cubitt Artists' new premises. Everything
is laser-printed so this approach offers
a flexible visual language that allows for
dynamic possibilities. Different letterpress
Cs are used for each exhibition – meaning
that all invitations, press releases, external
signage and the Cubitt website also have
to change, so introducing some variety.

Two specially designed typefaces
were employed throughout the project –
one for text purposes and the other for
fax transmissions. The 'fax typeface' is
generated from pixels that close up when
faxed so as to become more legible. A2
also designed a rubber stamp to introduce
a second colour for the press releases.

The items shown here include the
letterhead, press releases, fax sheet,
compliment slip, business cards and
one of the web pages.

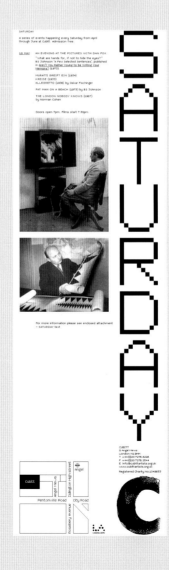

Top-left panel

CUBITT
Gallery and Studios
8 Angel Mews
London N1 9HH
T +44 (0)20 7278 8226
F +44 (0)20 7278 2544
E info@cubittartists.org.uk
www.cubittartists.org.uk

Cubitt Artists Limited
Company Limited by Guarantee
Registered in England and Wales No. 2748549
Registered Charity No. 1049653
Registered Office 315–317 Ballards Lane, London N12 8LY

Top-right panel

FAX TRANSMISSION

CUBITT
Gallery and Studios
8 Angel Mews
London N1 9HH
T +44 (0)20 7278 8226
F +44 (0)20 7278 2544
E info@cubittartists.org.uk
www.cubittartists.org.uk

F.A.O.

T:

F:

FROM:

T:

F:

DATE:

℗:

REF:

Cubitt Artists Limited
Company Limited by Guarantee
Registered in England and Wales No. 2748549
Registered Charity No. 1049653
Registered Office 315–317 Ballards Lane, London N12 8LY

Bottom-left panel

CUBITT
Gallery and Studios
8 Angel Mews
London N1 9HH
T +44 (0)20 7278 8226
F +44 (0)20 7278 2544
E info@cubittartists.org.uk
www.cubittartists.org.uk

CATHY WILKES
30 SEPTEMBER – 11 NOVEMBER 2001
OPENING: SATURDAY 29 SEPTEMBER 7 – 9PM

"There is an area, at which art and life intersect, which becomes physically present in Scottish artist Cathy Wilkes' carefully constructed installation *Mister So And So,...* It is a panoramic installation, full of delicate hints and fragile signs of courtship, dreams and projection, assumptions and knowledge... With a logic of her own, scepticism, and minimal means, her sculptures consist of found, thrown-away and neglected objects, furniture, from which she produces her own poetic and ambiguous narratives... Cryptic, but with their improvised 'povera' - charm oddly timeless, the single pieces assume the characters in a complex narrative of individuals and relationships."

- Angela Rosenberg, *Flash Art*, May/June 2001

For her solo exhibition at Cubitt, London Cathy Wilkes has made a large tableau of furniture, still life, fabric collage, linear wood sculptures and paintings.

A Cathy Wilkes publication, designed by Cathy Wilkes, Jörn Börtnagel and Yvonne Quirmbach and produced by The Modern Institute, Glasgow shall be launched at Cubitt on the opening night.

Cathy Wilkes shall be talking about her work at Cubitt on Saturday October 20th at 4pm.

Cathy Wilkes' recent solo exhibitions include: Transmission, Glasgow and Galerie Giti Nourbakhsch, Berlin (both 2001); Cathy Wilkes lives and works in Glasgow and is a member of the art and music group 'Elizabeth Go'.

Cubitt Artists Limited
Company Limited by Guarantee
Registered in England and Wales No. 2748549
Registered Charity No. 1049653
Registered Office 315–317 Ballards Lane, London N12 8LY

Bottom-right panel

CUBITT
Gallery and Studios
8 Angel Mews
London N1 9HH
T +44 (0)20 7278 8226
F +44 (0)20 7278 2544
E info@cubittartists.org.uk
www.cubittartists.org.uk

DAVID ROBBINS
2 DECEMBER 2001 – 20 JANUARY 2002
OPENING: SATURDAY 1 DECEMBER 7 – 9PM

ICE CREAM SOCIAL AND SYMPOSIUM
IN HIGH ENTERTAINMENT:
SATURDAY 12 JANUARY 4 – 9PM

Cubitt presents David Robbins's *Talent* (1986) – eighteen portraits of New York artists (Jeff Koons, Cindy Sherman, Jenny Holzer et al) photographed in the style of 10" by 8", black and white, actors' promotional headshots. Now regarded as Robbins's seminal work, the piece is at once an idiosyncratic recording of his peer group, historical evidence of a key moment in American art production, and a prompter to much subsequent discussion regarding the relationship between art and entertainment, the image of the artist, the tradition of the American maverick, the photographic, the documentary, hierarchies and categorisation, talent, context, curating, fetishism, visual pleasure, optimism...

On 12 January 2002, 4 – 9pm, David Robbins will be present at the gallery to host an Ice Cream Social, followed by a symposium on his pursuit of High Entertainment. Simple confections and light theatrical gestures will be offered for the enjoyment of all who choose to attend. Afterwards, guest speakers – among them David Robbins; writer and critic, Michael Archer; artist and writer, Padraig Timoney; artist, writer and curator at Cubitt, Polly Staple – will address aspects of the artist's achievement to date.

David Robbins and Cubitt have collaborated with Black Diamond Press on the production of a limited edition poster *The Frontiersman*, which will be available free at the gallery throughout the duration of the show.

David Robbins has had more than two dozen solo exhibitions of his work in the United States and Europe, and participated in many group exhibitions. He is the author of four books – *The Ice Cream Social* (1998), *The Dr Frankenstein Option* (1993), *Foundation Papers from the Archives of the Institute for Advanced Comedic Behavior* (1992), and *The Camera Believes Everything* (1998) – as well as numerous essays, interviews and satires. Currently residing in Milwaukee, Wisconsin, in the U.S., he is Assistant Professor in the graduate writing programme at the School of the Art Institute of Chicago. This is his first solo exhibition in Great Britain.

Opening hours: Wednesday – Sunday 12 – 6pm
Please note the gallery is closed 22 December 2001 – 4 January 2002

Cubitt Artists Limited
Company Limited by Guarantee
Registered in England and Wales No. 2748549
Registered Charity No. 1049653
Registered Office 315–317 Ballards Lane, London N12 8LY

BASIC COMMUNICATION SET

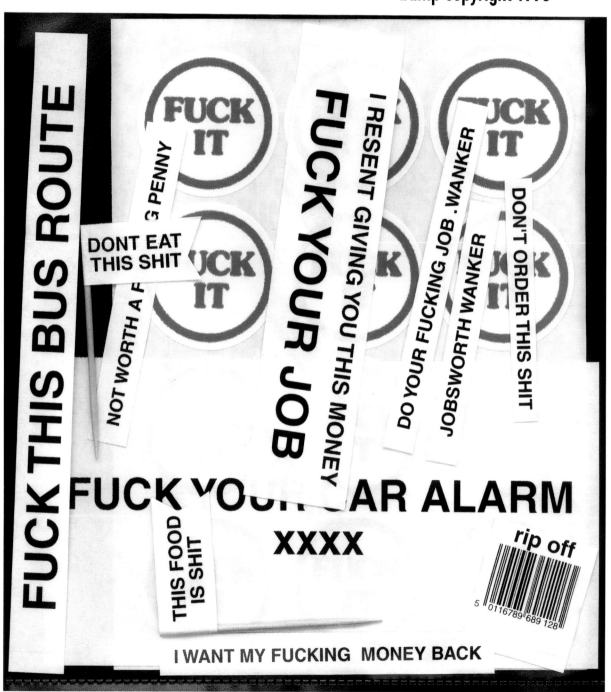

Sticker set (London, 1995–2002)

Mike Watson and Jon Morgan of Bump started making these stickers in 1995 when they were still students at the Royal College of Art. The set was designed in response to the fact that the British are not very good at complaining. 'We thought it was our duty to give a voice to the meek,' say Bump.

The first set was produced in an edition of 100. The stickers were all typeset in letterpress, and the 'FUCK IT' stickers also screenprinted by hand. 'It sold out in four days and it was clear that the idea had to be reproduced on a larger scale,' Bump explain – on the night of their degree show several people noticed a 'FUCK IT' sticker on the waistcoat of a waiter at an exclusive London restaurant.

Bump also made a children's set of building blocks [right], 'the idea being that there there is a fascination with kids' toys as collectable items and we were just adding to the junk.' The blocks were cut from one long piece of wood, the corners rounded by hand, then each block hand-sprayed and screenprinted on each of its sides.

Further versions of the sticker set followed, and have since been translated into Hindi, Japanese, German, French, Spanish, Italian, Chinese and Esperanto. Bump estimate that over 400,000 sticker sets have now been sold worldwide.

Mark Pawson

Book series (London 2000–2)

Mark Pawson runs a small but surprisingly profitable business from his studio, making and selling small books, badges, T-shirts and the like, all of which can be purchased directly through him. Many of the items he produces are made out of his or other people's waste material including comics, flyers, glossy fashion magazines, children's colouring books, braille hymn books, antique paper, wood-chip wallpaper and the odd pornographic magazine. Pawson's most successful pieces are usually made of the most simple materials.

This 35-page, hand-sewn edition of 300 books [above] uses the waste material left over from his printed paper badges. The circles vary in their arrangement and style according to the original scale and layout of the badges. Pawson describes how the overlays of multiple circles remind him of dot screens, moiré patterns, foam rubber

or books for children with windows they can peep through. The latest versions are positioned within a fixed grid of 35 badge blanks – the optimum number that fit evenly spaced on an A4 page. The title 'ooo ooooooooooooooooooooooooooooooo' is derived from this grid – 'that's 35 lowercase round o's, not oval-shaped capital O's or zeros,' Pawson points out.

32 varieties of plug-wiring diagrams have been collected to make another series of booklets, bound by three bits of cotton in the appropriate colours [opposite, above].

In 1995, Pawson bought a collection of antique, decorative book-binding papers from an old Jamaican shopkeeper in South London. Pawson, who taught himself bookbinding, envisioned using the paper for some future book project. Finding most of it still sitting on his shelves seven years later, he decided to bind them into small books which he now sells [opposite, bottom].

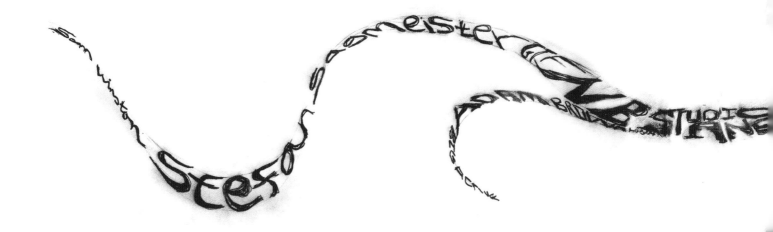

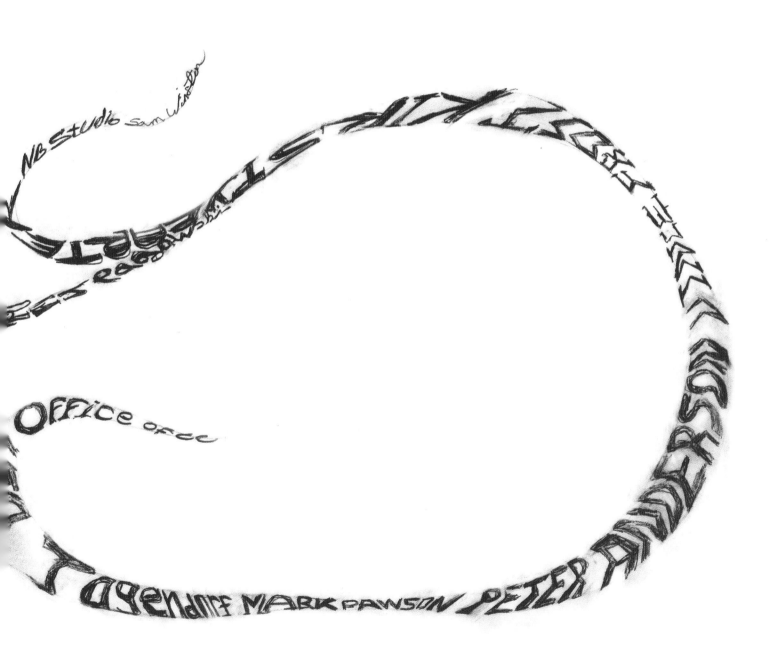

Glossary

Bible paper very thin paper, usually 40–60gsm in weight, typically used for bibles, telephone directories and dictionaries

Bitmap graphic image composed of a series of dots (also known as pixels or bits) that loses or gains quality when scaled up or down

Bleed to run an image off the edge of a trimmed page or sheet

Blocking stamping an image onto a surface to create a relief

CMYK separation of colours used in four-colour printing: cyan, magenta, yellow and black

Character any individual letter, figure, punctuation mark or sign in a typeface

Cut-and-paste interactive method for moving elements

Coated stock paper coated in china clay or similar material to give a smooth surface

Concertina folded pages folded in a zig-zag manner like the bellows of a concertina

Corporate identity imposed rule of design through which commercial companies, professional, charitable or state-supported bodies establish consultancy, coherence and recognisability in their publicity, promotion, stationery, packaging and distribution (also known as 'house style')

Debossing relief impression made with a die stamp, also known as 'blind embossing'

Die-cutting cutting often intricate shapes into paper or board by means of steel blades, which are custom-made to the required shape

Die-stamping stamping out raised, usually coloured, impressions on paper or board by means of matched dies

DIN Deutsch Industrie Norm: set of industry standards established in Germany in the 1920s and now used across Europe (subsequently adopted by the International Standards Organisation)

DPI Dots Per Inch: measurement determining the quality of bitmap graphics

Double hit printing a colour twice to increase the density of the ink

Embossing raised relief impression made by pressing a sheet between two interlocking blocks, one of which has the raised design on it, the other a matching depression

Endpapers first and last pages of a book, attached to the inside of hardback covers

EPS Encapsulated PostScript: vector graphic format that can contain both vector and bitmap graphics

Etching harnessing of the chemical effect of acid on metal to produce a printable image

Finish treatment of a paper surface to give the final effect, during manufacture or afterwards

Finishing any operation that follows work on the printing machine, such as laminating, binding and trimming

Flatplan diagram setting out the page-by-page arrangement of a periodical or book

Foil blocking printing method using metallic foil applied to a surface by a heated metal block

Font traditional term for a complete set of alphabets relating to one size of typeface, including upper- and lower-case roman, italic, bold, figures and punctuation marks

Fontographer computer software program used to create and modify typefaces using vector graphics

Four-colour printing process of producing printed colour using four separate plates to print cyan, magenta, yellow and black to give an impression of full colour. 'Special' colours such as silver can be added on as successive plates

French folding method of folding a page in half and binding along the open edge

Grotesque variety of sans serif typeface dating from the mid-nineteenth century

GSM Grams per Square Metre: standard measurement for weight of paper, which can be influenced by its thickness or density

Half-tones shades of grey in continuous-tone image converted to a series of dots before printing, because printing presses can only print solids. Dark areas have few dots, light areas have many. Most half-tones are created digitally via scanning

House style see 'corporate identity'

Illustrator computer software program based on vector graphics, used mainly for technical drawing

Imposition arrangement of pages for printing on sheets so they will be in the correct sequence when folded to form a section

Ink-jet printer computer output device using high-speed ink jets projected onto paper to create an image

Interface place where interaction occurs between two systems or processes, or between humans and machine

Japanese binding binding method where the thread is bound from the back to front of a book and around the outside edge of the spine

Justified lines of type set so as to fill the 'measure', or range visually on both sides

Kerning technique used whereby one character may be tucked into another, or the practice of compressing copy to fit into a line by 'minus' or abnormally close letter-spacing

Laser printer use of 'laser' (light amplification by stimulated emission of radiation): ie, high-energy light beam device as a means of transferring ink (in the form of toner) onto paper

Layout plan designed to show how the printed result would be obtained and to give some idea of how it would look

Letterpress traditional form of relief printing in which ink is applied to paper through pressure. Raised blocks of type made out of lead or wood are pressed onto the sheet, leaving an impression where they come into contact

Lithographic printing (or 'litho') most common printing process; in which the surface of metal (previously stone) is treated with chemicals so that some portion accepts ink and some rejects it. The design is transferred from this flat plate by means of a rolling cylinder

Mock-up rough simulation of a document showing the intended position of type matter and illustration

Monotype obsolescent system involving two machines (keyboard and caster) that produce metal type in single characters

Overlay transparent or translucent material laid over a piece of artwork or other original copy on which instructions may be shown

Overprint printed addition to job already printed

Paste up layout assembly used as a guide to the printer, not for reproduction

Perfect bound method of binding single leaves together using only glue

Photoshop computer software program used for the creation and editing of graphic images with retouching, colour correction and compositing functions

PostScript page description language used by printers, which essentially turns a design into a series of commands

QuarkXpress computer software program used for page layout of printed material including newspapers, magazines, books, posters etc

RGB Red, Green, Blue: colours on-screen are defined in terms of a combination of these three colours, which are based on the light spectrum, not pigments

Saddle-stitched standard method for binding brochures and magazines where pages are gathered to be bound and stapled through the folded edges

Sans serif typeface without finishing strokes at the ends of the character elements

Screenprinting traditional form of screen process where a rubber squeegee forces ink through a fine screen of fabric or metal onto which a stencil is fixed

Sewn section method of binding whereby a group of eight or sixteen folded pages are gathered and sewn through the folded edges. The sections can be bound together to form a complete book

Singer-sewn method of binding that stitches a book by sewing through the front to the back using an industrial version of the household sewing machine. Used mainly on loose-leaf and French-folded documents

Thumbnail miniature sketch or design used to view consecutive layouts

Type Foundry commercial practice that creates typefaces

Typography the art and technique of working with type/layout of typeset and accompanying graphic material for reproduction

Uncoated stock paper with rougher surface than coated paper but more opaque and bulky

Vector graphic image made up of lines and curves so it can be scaled up or down without loss of quality

Bibliography

Aldersley-Williams, H *et al* (1990) *Cranbrook Design: The New Discourse* Rizzoli, New York

Bierut, M, W Drenttel, S Heller and K H Kolland [eds.] (1996) *Looking Closer: Critical Writings on Graphic Design* Allworth Press, New York

Bierut, M, W Drenttel, S Heller and K H Kolland [eds.] (1997) *Looking Closer 2: Critical Writings on Graphic Design* Allworth Press, New York

Bierut, M, W Drenttel, S Heller and K H Kolland [eds.] (1999) *Looking Closer 3: Critical Writings on Graphic Design* Allworth Press, New York

Blackwell, L (1995) *The End of Print: The Graphic Design of David Carson*

Blauvelt, A (Spring 2000) 'Towards a complex simplicity' *Eye* vol. 9, no. 35

Booth Clibborn Editions (2001) *Specials*

Broos, K and P Hefting (1998) *Dutch Graphic Design: A Century* Phaidon Press, London

Bruinsma, M (Summer 1997) 'Learning to read and write images' *Eye* vol. 7, no. 4

Carter, S (1995) *Twentieth Century Type Designers* Lund Humphries, London

Catterall, C (2001) *Specials: New Graphics* Booth-Clibborn Editions, London

Cieslewicz, R (1993) 'Interview' *Eye* vol. 3, no. 9

Collings, M (2001) *Art Crazy Nation* 21 Publishing, London

Culture Foundation (1993) *Stasys* Warsaw

Dawson, B (1999) *Street Graphics India* Thames & Hudson, London

Dawson, M (Autumn 2001) 'Same name different face' *Eye* vol. 11, no.41

Fletcher, A and Myerson, J (1996) *Beware Wet Paint* Phaidon Press, London

Fletcher, A (2001) *The Art of Looking Sideways* Phaidon Press, London

Foges, C (July 2001) 'Mind games' *Blueprint* no. 185

Frayling, C (1987) *The Royal College of Art: One Hundred and Fifty Years of Art & Design* Barrie & Jenkins, London

Gander, R (Summer 2001) 'Joep van Lieshout: artist, sculptor, designer, scientist, inventor, racing car-driver' *Dot Dot Dot* no. 3

Garland, K (1966) *Graphics Handbook* Studio Vista, London

Garland, K (1989) *Graphics Design and Printing Terms: An International Dictionary* Lund Humphries, London

Gerber, A (Autumn 2001) 'Honour thy error' *Eye* vol. 11, no. 41

Glaser, M (1973) *Graphic Design* The Overlook Press, New York

Glaser, M (2000) *Art is Work* Thames & Hudson, London

Greiman, A (1990) *Hybrid Imagery: the Fusion of Technology and Graphic Design* Architecture, Design and Technology Press

Haase, A & L ten Duis [eds.] (1999) 'The world must change: graphic design and idealism' *Sandberg Instituut* no. 18

Held, U (Winter 1996) 'Read this aloud' *Eye* vol. 6

Heller, S (1999) *Design Literacy: Understanding Graphic Design*, Allworth Press, New York

Hollis, R (1994) *Graphic Design: A Concise History* Thames & Hudson, London

Huygen, F and H C Boekraad (1997) *Wim Crowel: Mode en Module* Uitgeverij 010, Rotterdam

Hyland, A (2001) *Pen and Mouse* Lawrence King Publishing, London

Ivins, W M (1992, first published 1969) *Prints and Visual Communication* MIT Press, Massachusetts/London

Jury, D (2001) 'Design process', *Graphics International* no. 84

Kindel, E (Spring 2002) 'Colour overprinting: constructed images by printers and designers' *Eye* vol. 11, no. 43

King, E [ed.] (2001) *Graphic Thought Facility: Bits World* Gabriele Capelli, Switzerland

Kinross, R (1992) *Modern Typography: An Essay in Critical History* Hyphen Press, London

Kinross, R (2000) *Anthony Froshaug* Hyphen Press, London

Küsters, C and E King (2001) *Restart: New Systems in Graphic Design* Thames & Hudson, London

Lupton, E (1996) *Mixing Messages: Contemporary Graphic Design in America* Thames & Hudson, London

Lupton, E and J Abbott Miller (1999) *Design Writing Research: Writing on Graphic Design* Phaidon Press, London

Maeda, J (1999) *Design by Numbers* MIT Press, Massachusetts

Maeda, J and N Negroponte (2000) *Maeda @ Media* Thames & Hudson, London

Martens, K (1996) *Printed Matter* Hyphen Press, London

Mau, B (2000) *Lifestyle* Phaidon Press, London

Meggs, P B (1983) *A History of Graphic Design* John Wiley & Sons

Müller, L (1995) *Josef Müller-Brockman: Pioneer of Swiss Graphic Design* Lars Müller Publishers, Baden

Myseron, J (2001) 'Letterpress at the RCA' *Baseline* no. 32

Potter, N (1989, first published 1969) *What is a Designer?* Hyphen Press, London

Poynor, R (1998) *Design Without Boundaries: Visual Communication in Transition* Booth-Clibborn Editions, London

Poynor, R (1991) *Typography Now: The New Wave* Booth-Clibborn Editions, London

Poynor, R (1994) *Typography Now: The Next Wave* Booth-Clibborn Editions, London

Poynor, R (Summer 1997) 'Other spaces' *Eye* vol. 7

Poynor, R (2001) *Obey the Giant* August/Birkhaüser, London

Prat, R & T Sakamoto [eds.] (2001) *Holland Design: New Graphics* Actar, Barcelona

Rock, M (Spring 1996) 'The designer as author' *Eye* vol. 5, no. 20

Rogers, R (1997) *Cities for a Small Planet* Faber & Faber, London

Sagmeister, S (2001) *Made You Look* Booth Clibborn Editions, London

Seago, A (1995) *Burning the Box of Beautiful Things: The Development of a Postmodern Sensibility* Oxford University Press, Oxford

Shaughnessy, A and J Haus (1999) *Sampler* Lawrence King Publishing, London

Shaughnessy, A and J Haus (2000) *Sampler 2* Lawrence King Publishing, London

Shaughnessy, A (Winter 2001) 'Uncoated board' *Eye* vol. 11, no. 42

Spencer, H (1960) 'Stedelijk Museum Catalogues' *Typographica* no. 10

Spencer, H (1983) *Pioneers of Modern Typography* MIT Press, Massachusetts (revised edition)

Steinberg, S H (1961) *Five Hundred Years of Printing* [2nd edition] Harmondsworth

The Foundation of Polish Culture (1988) *Andrzej Pagowski* Warsaw

Twyman, M (1970) *Printing 1770–1970* Eyre & Spottiswoode, London

Vanderlans, R and Z Licko (1993) *Emigre The Book: Graphic Design into the Digital Realm* Van Nostrand Reinheld, New York

Wainwright, A (1957) *The Far Eastern Fells* (Book 2) Westmorland Gazette, Kendal

Weingart, W (2000) *My Way to Typography* Lars Müller Publishers, Baden

Williams, N (1995) *Paperwork* Phaidon Press, London

Worthington, M (Autumn 1999) 'Entranced by motion, seduced by stillness' *Eye* vol. 9, no. 33

Wozencroft, J (1998) *The Graphic Language of Neville Brody* Thames & Hudson, London

Wróblewska, D (1988) *Polish Contemporary Graphic Art* Interpress, Poland

Holjes, W (2001) *TypeStyle Mixer* Lawrence King Publishing, London

Index

Contacts

David James	david@dqjltd.co.uk
Jeremy Johnson	j07887523974@hotmail.com
Johnson Banks	Michael@johnsonbanks.co.uk
Alan Kitching	no email
Karel Martens	km@werkplaatstypografie.org
Mevis & van Deursen	mevd@xs4all.nl
MMD	info@mmd-ltd.com
Mauren Mooren & Daniel van der Velden	mooren@dds.nl
John Morgan	John@bookdesign.co.uk
Fraser Muggeridge	frasermuggeridge@onetel.net.uk
Studio Myerscough	post@studiomyerscough.demon.co.uk
NB Studio	b.stott@nbstudio.co.uk
Office of CC	ver@xs4all.nl
Mark Pawson	mark@mpawson.demon.co.uk
David Pearson	davidpearson_@hotmail.com
Stefan Sagmeister	SSagmeiste@aol.com
Katrin Schoerner	kschoerner@metadesign.de
Pierre di Sciullo	pourpds@free.fr
Mike Simons	goggles@adbusters.org
Andrea Speidel	A.Speidel@t-online.de
Eric Wear	sdwear@polyu.edu.hk
Micha Weidmann	michaweidmann@gmx.ch
Henry White	henrywhite@henrysmail.com
Sam Winston	w_sam@yahoo.com
Manuela Wyss	manuela@hingston.net

Acknowledgements

Many thanks to Hannah Ford for introducing this project to me.
Thank you to all who provided advice, help and information, and
especially to Stuart Bailey, Peter Brawne, Susanna Edwards,
Ken Garland, Luke Herriott, John Morgan, Kate Noel-Paton,
Lucy Odling-Smee and Xavier Young. Thank you also to Adam
Brown, Christian Küsters, Marysia Lewandowska, Julia Morlok,
John and Rosamond Odling-Smee, Julia Peglow, John Walters and
Six Wu. Finally, enormous thanks to Peter Anderson, Ally Ireson
and Fraser Muggeridge.

And warmest thanks to all contributors.